PERSPECTIVE AND COMPOSITION

PERSPECTIVE
AND
COMPOSITION

BARRON'S

CONTENTS

THE ORIGINS OF COMPOSITION

The basis of artistic composition lies in the intuitive vision of the creator—the particular sensibility with which an artist organizes the objects in a work. As Delacroix said, "When dealing with the great artists, what we call their creativity is nothing more than their special way of seeing, ordering, and reproducing nature." But every artist's vision is influenced by the spirit and outlook of the time in which he or she lives. Hence, the cultural milieu has a profound impact on the vision of all artists.

Prehistoric Art

Some cave paintings of the Paleolithic and Mesolithic periods (35,000–7,000 B.C.) display rudiments of composition. Certain war and hunting scenes reveal a concern for the unity of the whole, which is achieved through movement relating the figures among themselves. The artists who executed these works painted on the walls and ceilings of caves. Though they had no fixed rules for ordering their works, they did possess sufficient sensibility to achieve dramatic effects. Nonetheless, the absence of a defined format—a frame in which to place the composition —makes prehistoric art only a remote precursor of our modern-day notion of pictorial composition.

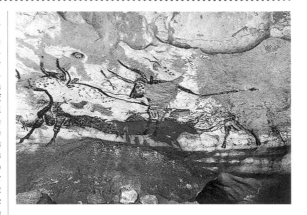

Animals painted on a rock wall at the Lascaux Caverns in France.

Egypt

It was the Egyptians, thousands of years later, who were the first to use a fixed compositional system. Unlike the prehistoric cave painters, the Egyptians designed their works for a given set of dimensions: the walls of their temples and tombs. This created the need to order, distribute, and adapt forms and sizes—that is, to compose. In addition, within the general com-

The Birth of Composition

Measurement and mathematics were born of agriculture and architecture: when humans began cultivating the land, they had to mark off their fields; when they constructed houses and temples, the parts had to fit together to enclose a predetermined space. Artists, forced to place limits on their works of art as well, came up with ways of distributing forms in interiors according to specific dimensions and proportions. This occurred during the Neolithic period, which started approximately 6,000 to 8,000 years ago.

Wall paintings of the Middle Kingdom (tomb of Nakht, in Thebes). Artistic composition arises with the development of architecture and the need to organize pictorial space.

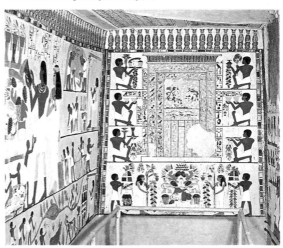

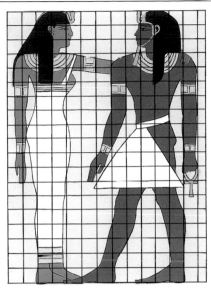

Compositional grid corresponding to the canon fixed during the Middle Kingdom. The figure of the pharaoh is 18 fists high.

MORE INFORMATION
• Baroque Innovations in Composition **p. 16**
• Foreshortening **p. 70**

In about 320 B.C. the sculptor Lysippus proposed a new, more slender set of proportions with his sculpture *Apoxyomenus*, which measured eight heads. Lysippus, who also made many statues of Alexander the Great, broke definitively with the ideals of the Classical period. He also abandoned the traditional frontal pose, with shoulders turned in the direction opposite to the hips.

During the Hellenistic period, which began with the military conquests of Alexander, the figure's freedom of movement became complete. Spurred on by their propensity for elegance and slenderness, artists generally used the canon of eight heads, but often reached nine or even more in their figures, demonstrating perfect mastery of anatomy and movement.

position of their works, the Egyptian artists invented a series of measurements designed specifically for the representation of figures.

The Egyptian Grid

In 1842, a team of German archaeologists discovered a grid covering the wall paintings of a tomb. It was not long before more and more grids were discovered. It was evident that these lines served as a fixed system to aid in the composition of a wall painting. The basic unit of measure from which the artists constructed their figures was the fist (the average distance between knuckles and wrist). We now know that they used other units as well: the *small elbow*, which measured four fists; the *royal elbow*, measuring five fists; and so on.

Greece

The conquest of realistic portrayal occurred in the Greece during the Classical period (fifth century B.C.). Greek artists achieved accurate proportions in the parts of the body and natural movement in their figures. In addition, their scenes showed a unity of space. The Greek artists partially solved the problem of the third dimension. They creat-

ed a sense of depth and space by superimposing figures and by using foreshortening. Foreshortening makes an object or a figure look as if it were projecting toward the viewer; as a result, some of its parts appear in perspective.

Another advance in figurative representation occurred when the sculptor Polyclitus established the first canon (rule or norm) for human proportions. It allowed seven and a half heads for the height of the male figure. This appeared in concrete form in one of the most beautiful (and widely copied) sculptures in history: the *Doryphorus* (*Spearbearer*).

From the time of Polyclitus, Greek figures moved with natural grace. This movement was generally expressed through a particularly harmonious pose characterized by the contrast between the positions of shoulders and hips. The leg standing firmly on the ground (on which the figure rests) causes the respective hip to rise, while the shoulder of this same side is in a somewhat lower position than the other shoulder.

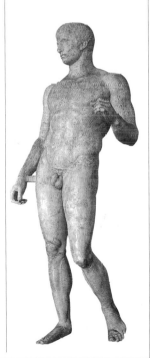

A Roman copy of Polyclitus' Doryphorus. *This work imposed the Classical canon of seven and a half heads for the male figure.*

BEFORE PERSPECTIVE

The essentially flat compositions of ancient art contain various elements that herald the appearance of true geometric perspective. These are not failed attempts at perspective, but real compositional solutions. They evoke the third dimension, alluding to it through ingenious, intuitive procedures of great visual force and aesthetic quality.

Rome

The Romans were great admirers of Greek art. Continuing in the Greek tradition, they also developed several specific subject areas (or genres), including the portrait and the still life. Their great murals of gardens, houses, and streets show a deep capacity for imaginative composition. These decorative scenes display multiple perspectives and panoramic depth. The still lifes demonstrate innovative compositional characteristics that, in their simplicity and naturalness, have influenced many artists up to the present day.

Medieval Composition

With the onset of Christianity, art lost its realist qualities. One of the common characteristics of Medieval art, in the Byzantine Empire as well as in the West, is flatness. The figures and scenes were executed with objectives that were more symbolic and ornamental than realist. Decorative and figurative aspects were given equal importance and attention. In some northern European manuscripts and southern Romanesque murals, the figures follow a repetitive, schematic pattern of stylized forms.

The Gothic Period

Beginning in the twelfth century, artists began to leave behind the stylized, schematic composition of the Romanesque. Instead, they gave increasing attention to particular details— the elegance of garments, the special material qualities of objects and plants. Above and beyond the intention to reproduce reality, Gothic artists were obsessed by the desire to dazzle the viewer with the exquisite and luxurious characteristics of their paintings. Particularly outstand-

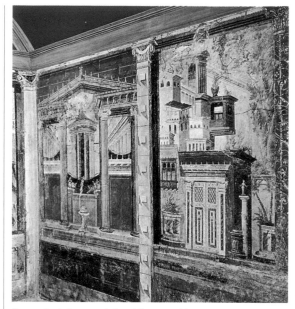

Perspective in Roman paintings follows an arbitrary pattern and does not conform to a single vanishing point.

ing in Gothic compositions are the backgrounds and golden detail work, the meticulously represented garments, and the floors with ornamental and colorful tiles. The general effect is always a certain air of fantasy, enhanced by the glazed brilliance of the colors. This style developed in response to the tastes of the well-to-do and aristocratic classes of the period.

Sacred Art

Ornamentation and piety are constants in Byzantine art, nearly all of which was religious. To achieve a powerful reverential effect, the strictly flat and frontal figures of Christ and the saints were crowned by halos that enclosed the concentric circles formed by the hair and face of the figure.

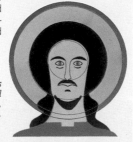

The religiosity of medieval figures is based on very rigid compositional schemes such as that of this head, consisting of concentric circles.

Medieval Perspective

The flat nature of medieval art led painters to seek particularly ingenious solutions to the problem of representing depth. This reconstruction of an Ottonian codex shows how the artist resolved the problem of architectural perspective. The columns are shown frontally and the perspective of the dome is achieved within the strict symmetry in which the figures and the rest of the compositional elements will be placed. Though scientific methods of perspective were several centuries away, painters of this period were able to handle complex subjects with convincing authority.

Ottonian codex (about 1020). Bayerische Staatsbibliothek, Munich.

The medieval solution to the problem of perspective was based on flattening shapes and maintaining symmetry.

A view in correct perspective of the architecture represented in the medieval codex.

Gothic Symmetry

The most widespread compositional format of the Gothic period was the altarpiece consisting of panels that reveal various scenes from the lives of the saints. These works are remarkable for the strict symmetry used in the distribution of the episodes, which combine to form a complex structure. Though each scene is spatially unified in and of itself, the side panels are subordinate to the larger central composition. The perspective of these paintings is strictly functional and does not attempt to create spatial unity. Rather, it seeks to facilitate the observer's comprehension of the narrative sequence of the episodes.

A Gothic altarpiece. The multiple scenes, which have no spatial continuity, are grouped according to the principle of symmetry.

MORE INFORMATION

• Unity within Variety **p. 20**
• The Surface **p. 36**

ORIENTAL PERSPECTIVE AND COMPOSITION

Oriental art followed its own path, virtually unaffected by Western developments. Representation in the East ignored European enthusiasm for geometry and maintained the flatness of the figure for centuries. But this art also had various methods of expressing space and depth, as intricate as those of the West and of unequaled refinement.

Islam

Islam was founded in the seventh century by the Prophet Muhammad. One hundred years later it was the religion of an immense territory stretching from the north of India to the Atlantic. The Koran, the sacred book of the Muslims, allowed the representation of figures, but the first Islamic theologians prohibited it. Western Islamic art limited itself to the creation of stylized arabesque patterns and decorative elements. Figurative representation returned in the sixteenth century when the Mogul Dynasty came to power and the first school of miniaturists in the Persian style was founded. The diminutive figures and plants, which stand out clearly against the background, are distributed within a perfectly balanced, decorative whole.

Narrative scenes of court life, hunting, and warfare are represented on a single frontal plane. The perfection of detail, the brilliance of colors, and the vivacity

Frontispiece of a Koran (1189). Istanbul University Library.

of the anecdote overruled realist considerations in the representation of light, volume, and shadow.

India

Classical Indian painting (about 800 A.D.) was inspired by figures engaged in dance. Frescoes of superior quality, which had already demonstrated a predilection for sinuous lines and ornamental richness, became the model for the illustration of manuscripts—the dominant genre from the tenth century onwards. In the year 1526, the Mogul Dynasty came into power, and with it came the influence of Islamic art. Thereafter, Indian artists used an elevated viewpoint and an elementary type of perspective limited to the representation of buildings. The brilliance of colors and vivacity of the anecdote relegated realist aspects to a secondary role.

Indian art is rich and colorful, with an original feeling for nature. The most beautiful masterpieces of Mogul painting are the miniatures done in the early eighteenth century. These works demonstrate an amazing mastery of technique. The meticulous quality of the drawing and detail make them a source of endless admiration. The portrayal of depth occupied a secondary place for the Indian artist. Lacking interest in realism, their intent was to create a purely narrative and ornamental art. They placed all means at the service of clarity of description and the aesthetic pleasure of ornamental forms and colors.

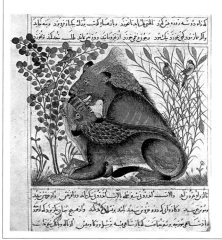

Scene from a Persian bestiary (1298). Morgan Library, New York.

Oriental Perspective

This work is an illustration done in the Mogul style. It is a narrative episode representing a prince's dream. A female demon appears in the interior of the prince's chamber and speaks with the protagonist. The artist knew perfectly well how to achieve a convincing perspective of the chamber, but chose to distort the back wall, probably to emphasize the surreal and mysterious nature of the dream.

The adjoining diagram clearly shows the incongruence of the perspective in this Persian work. Mogul School (1602). Apparition of a Female Demon. Chester Beatty Library, Dublin.

Chinese Perspective

The most defining characteristic of Chinese pictorial composition is found in landscape paintings. Scholar-artists devised a method to express depth without the aid of geometric perspective. This technique is known as the *rising eye-level viewpoint*. The foreground of the landscape appears at the bottom of the painting; the middle ground above it; and the background, in turn, above the middle ground. The trees, stones, rivers and other elements diminish in size as we rise into the upper zones of the painting. The sensation produced by this style is generally that of a monumental rocky elevation or an extensive panorama seen from a bird's-eye point of view.

MORE INFORMATION

- The Surface **p. 36**
- Composing a Landscape **p. 60**

Japanese Composition

Traditional Japanese scroll painting utilizes a long, lengthwise format to depict historical or literary events in narrative form. The scrolls, which are affixed to spindles at either end, are meant to be rolled as they are viewed successively—much like reading a text. This style makes for a spread-out composition without a central motif or subject. It provides a succession of scenes presented in chronological order.

In the mid-eighteenth century, the influence of Western art stimulated the representation of the figure as the central motif. Often these are of elegant women placed in interiors. Much of the painter's attention is concentrated on the decorative details of garments and hairstyles.

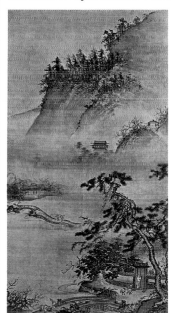

Landscape attributed to Tai Tsin (early fifteenth century). Palace Museum, Taiwan.

CLASSICAL COMPOSITION

Artistic composition reached its peak during the Italian Renaissance. The invention of the science of perspective opened new frontiers. The great frescoes, portraits, and mythological scenes demanded new methods. Painters, sculptors, and architects embarked on an effusion of creative activity without parallel in the history of art. This was the culminating moment of perspective and pictorial composition.

The Renaissance

During the Renaissance, artists concentrated on the appearance of reality in figures, faces, landscapes, buildings, and so on. Medieval flatness and the decorative portrayal typical of Gothic art were left behind. An awareness of the real world had returned in full force. As early as the fourteenth century, Giotto (c.1266–1331) created compositions in three dimensions with figures that move and interact in a realistic fashion. Decorative golden backgrounds slowly disappeared to make way for the portrayal of simple architecture and landscapes with trees, rocks, and figures in the distance. Artists copied Roman statues, rediscovered the Classical canons of proportion, and systematically applied them to compositions in which the human figure had become the central motif.

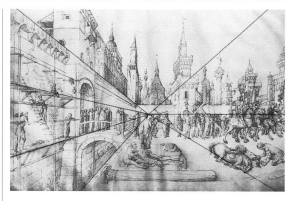

Drawing by Jacopo Bellini (1395–1471) with perspective lines superimposed to show the subordination of the entire scene to the receding lines that meet at the vanishing point.

Space in Perspective

During the quattrocento (an Italian abbreviation for the fourteen hundreds—in other words, the fifteenth century) artists were obsessed with the representation of space. The problem was to obtain the effect of depth and distance, or three dimen-

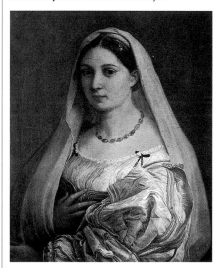

Raphael. Portrait of a Woman with a Veil. Pitti Palace, Florence. A portrait done in classical style.

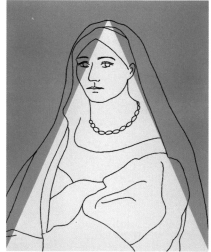

Outline of Raphael's painting showing the pyramidal composition.

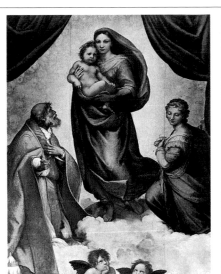

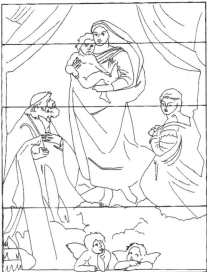

Raphael. The Sistine Madonna. *Pinakothek, Dresden. The composition of this work is entirely based on the golden section.*

Diagram showing the divisions obtained using the golden section in Raphael's painting.

sions, on a two-dimensional surface. The solution was to be found in perspective. Mathematical perspective was one of the great accomplishments of the Renaissance. Geometry provided the rules to describe the way objects are reduced in size as they recede into the background. The intent was to give the illusion that real space stretched beyond the flat surface of the painted canvas or wall, based on the viewpoint of the observer. All elements of the painting were depicted according to that viewpoint. At this time artistic composition gained its most solid and enduring foundation.

The Classical Method

The three greatest masters of the Italian Renaissance, Leonardo da Vinci (1452–1519), Michelangelo (1475–1564) and Raphael (1483–1520), established the principles of pictorial classicism. This style, based on the achievements of ancient Greece and Rome, would dominate all the schools of Europe as the model of perfection for centuries. The principles of classi-

cism, in the words of Michelangelo, require the artist to be led by "reason, art, symmetry and proportionality, selectivity, and certainty of what is to be done." This is a forceful declaration of principles that underlie classical art. Works in the classical tradi-

Drawing and Color

In the sixteenth century, the gap between two ways of perceiving painting widened. One concept took drawing to be the principle compositional element; the other used color above all other means. The Italian word *disegno* combines both drawing and design in a single concept. Roman and Florentine artists drew with well-defined lines, clearly delineating and isolating forms. In Venice, on the other hand, a great school of colorists composed paintings by fusing different masses of color into a chromatic whole.

tion are based on simple, solid compositions in which clarity is the norm and, very often, symmetry is the principle balancing element. The most characteristic of all classical compositions is a triangle whose base occupies the entire lower part of the painting. Most of Raphael's works are based on this pattern.

The Golden Section

The principle of the golden section or golden mean was known since antiquity, but it is in the Renaissance that artists begin to use it systematically as a method of distributing forms within a painting, thereby guaranteeing the harmony and coherence of the whole. The geometrical rigor of this principle was combined with the science of perspective to produce works of unparalleled compositional balance and perfection.

MORE INFORMATION

• Brunelleschi's Demonstration **p. 14**
• The Golden Section **p. 22**
• Before Perspective **p. 8**

THE INVENTION OF PERSPECTIVE

After the innovations of Giotto, the theory and practice of perspective was impelled by a series of brilliant artists. Brunelleschi was the first to formulate its fundamental principles. In fact, the Renaissance can be divided into two periods, one before and one after Brunelleschi. After him, painting took a decisive turn towards reality and naturalism.

Conquering Perspective

During the fourteenth century, some Italian artists began trying more realistic methods of representation than those of the Gothic period—the style that had long dominated painting throughout Europe. One of the most famous experiments was that of the Sienese painter Ambrogio Lorenzetti (1319–1347), who created an enormous fresco showing daily life in the city and in the countryside. This fresco was not compartmentalized as in the Gothic style; rather, it encompassed a multitude of scenes in perfect spatial continuity. This was a great innovation and a major step towards the achievement of rational perspective. But precisely because of the need to encompass such a wide area, the panorama does not have a single point of view. Instead, there are several viewpoints (and many vanishing points), which vary as the scenes change. The definitive theory of perspective would not be formulated for almost another century.

The Basic Concepts of Rational Perspective

The Florentine architect Filippo Brunelleschi (1377–1446), a brilliant and versatile artist, was the first to demonstrate the principles of rational perspective. These are very simple and are based on drawing from a single point of view, which represents the eye of the observer. Parallel receding lines (called vanishing lines) converge at a single vanishing point, which is located on the horizon line at the same height as and directly in front of the viewer. This explanation includes almost all of the basic concepts of drawing in perspective. These elements shall henceforth be referred to by the following initials: point of view (PV), vanishing line (VL), horizon line (HL), and vanishing point (VP).

Brunelleschi's Demonstration

In 1420, Brunelleschi demonstrated his theory of rational perspective. He meticulously painted the Plaza de la Signoria in Florence as seen from the entrance to the cathedral. When he had finished, the architect made a hole in the center of the horizon line, precisely at the vanishing point where the parallel lines of the street leading to the plaza converged. By looking through the hole from behind the painting, the eye of the observer is positioned at the point of view. A mirror held in front of the painting would then reflect a perfect replica of the

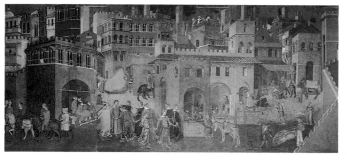

Ambrogio Lorenzetti. The Effects of Good Government. *Public Palace, Sienna. This is only a fragment of the vast painting composed from several different viewpoints.*

Perspective diagram of Lorenzetti's work showing some of the vanishing lines and the different vanishing points to which they lead.

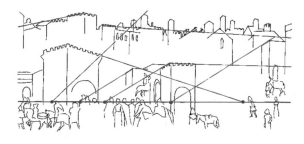

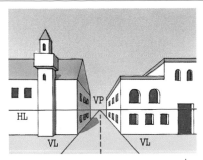

Brunelleschi's perspective method is based on the concepts of the vanishing line (VL), horizon line (HL), and vanishing point (VP).

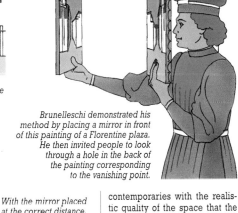

Mirror

Painting

Brunelleschi demonstrated his method by placing a mirror in front of this painting of a Florentine plaza. He then invited people to look through a hole in the back of the painting corresponding to the vanishing point.

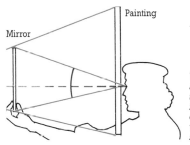

With the mirror placed at the correct distance, the observer had the illusion of being in the exact place (point of view) from which the scene was painted.

One of the first to incorporate the new method into his painting was Masaccio (1401–1428). He did it with absolute rigor, producing works that impressed his contemporaries with the realistic quality of the space that the figures occupied.

After Brunelleschi, the concepts of linear perspective, overlapping forms, objects receding into space, and use of a vanishing point became essential elements of drawing.

MORE INFORMATION
· Classical Composition **p. 12**
· Parallel Perspective **p. 76**

plaza as seen from the door of the cathedral.

Although Brunelleschi never explained the principles behind the rational perspective method, it was clear that he was familiar with the basic concepts. From the day of his ingenious demonstration, he was acclaimed as the inventor of the method of geometrical perspective.

Repercussions of the New Method of Perspective

The visual naturalism that derives from the Brunelleschi method radically influenced artistic composition of the Renaissance. From that moment artists began abandoning Medieval methods based on intuition and approximate perspectives (with vanishing points at different levels, several different points of view, and so on) to adopt the rational approach introduced by the great architect.

Perspective and Architecture

There is nothing surprising about the fact that it was an architect who introduced the concept of rational perspective to painting. Brunelleschi's perspective, which is based on geometry, is best revealed in views of buildings composed of ordered lines and geometrical forms. When Renaissance artists wanted to demonstrate their grasp of perspective, they always resorted to architectural subjects. In this painting by Raphael, the central point is the entrance to the building in the background. The figures are placed on a horizontal area in the foreground, which is paved to make the receding lines clearly visible.

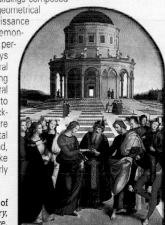

Raphael. The Marriage of the Virgin. *Uffizi Gallery, Florence.*

BAROQUE INNOVATIONS IN COMPOSITION

The Baroque age lasted from the late sixteenth century until the middle of the eighteenth century. During this long period, artists introduced a great number of compositional innovations that are still evident in today's pictorial styles. These innovations reveal a taste for dramatic and spectacular scenes, as well as a naturalistic view of reality.

Aerial Perspective

It was Leonardo da Vinci who first began speaking of the atmosphere—the air or space that exists and circulates between the objects, figures, and other elements of a landscape. He realized that distance tends to blur contours, that the edges of objects seem to blend into their surroundings, and that far-away mountains sometimes appear to disappear into the air. He was the first to blend contours in order to integrate them into a compositional whole, making the more distant objects appear blurred and undefined. This method of representing the atmosphere to convey a sense of distance, known as *aerial perspective,* is a crucial contribution to the art of painting. Once aerial perspective was understood, it was only a matter of time before *chiaroscuro*—the use of light and dark to render masses—would emerge.

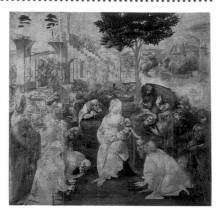

Leonardo da Vinci. The Adoration of the Magi. Uffizi Gallery, Florence. Leonardo's work is the first to be done in aerial perspective.

Chiaroscuro was a revolutionary innovation because it obscured aspects of the real world, which until then had always been visible. Many of Caravaggio's contemporaries refused to accept his invention and some even called him the "antichrist of painting." In the end, his ideas became the norm and the chiaroscuro technique was adopted by all the great artists of the Baroque. They became experts in the play of light and the art of showing only part of the bodies of their figures, leaving dark large portions of their paintings.

Chiaroscuro

It was Caravaggio (1573–1610) who developed the technique of chiaroscuro. He was the first painter to leave large areas of his works in almost complete darkness, while illuminating other areas with dazzling artificial light. The violent contrast between lights and darks stood in contradiction to the Renaissance ideal of harmonious, balanced clarity. In the chiaroscuro of the Baroque, shapes were defined by the contrast between light and dark; and large areas were often left in the uncertainty of darkness. The results were dramatic, even theatrical effects.

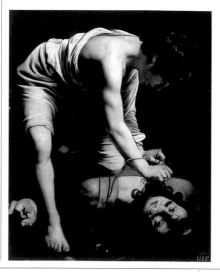

Caravaggio. David's Victory Over Goliath. Caravaggio is the great innovator who brought chiaroscuro to Western painting.

Dynamic Composition

Peter Paul Rubens (1577–1640) was influenced by Caravaggio's work, but his strong personality led him to create fully original art—often favoring monumental scenes of great dynamism. He filled these works with groups of huge figures in motion. Drawing and color were treated with equal intensity. Rubens painted compositions with curves, spirals, and diagonals, creating counterpoised rhythms and forces with the resulting effects of instability and transience. The dynamic composition introduced by Rubens was to become another hallmark of the Baroque style. Spiral compositions require a level of creativity that goes beyond naturalism. In such works, perspective is simply an auxiliary element.

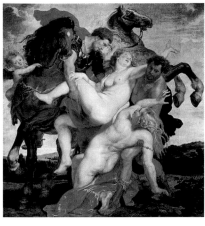

Rubens. The Rape of the Daughters of Lysippus. Alte Pinakothek, Munich. One of the most famous examples of a dynamic composition.

Foreshortening

Foreshortening is the art of representing figures or parts of figures at an angle that is perpendicular or oblique to the plane of the painting. This technique, which results in the reduction of proportions normally required by the rules of perspective, is another of the great innovations of the Baroque period. Foreshortened figures have a particular dynamism that is in keeping with the taste of the period. It allowed for more daring compositions and was used by many artists to create highly spectacular effects.

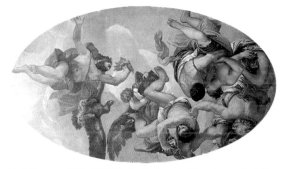

Paolo Veronese (1528–1588). *Jupiter Destroys the Vices. Louvre, Paris.* Foreshortening is one of the principal achievements of Baroque composition.

MORE INFORMATION

• Chiaroscuro **p. 46**

The Baroque Diagonal

A typical Baroque work was based on one or several diagonal lines that crossed the canvas from one side to the other. Often, this technique substituted for geometric perspective. The diagonals themselves caused a sensation of movement into three-dimensional space. Consequently, many Baroque painters began a work by drawing long diagonal lines and then placing the figures along them.

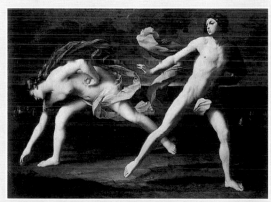

Guido Reni (1575–1642). **Hippomenes and Atlanta.** *El Prado, Madrid. The extended legs of each figure follow the compositional diagonal lines typical of Baroque painting.*

MODERN COMPOSITION: IMPRESSIONISM TO THE PRESENT

During the late eighteenth century, the Baroque contributions to the art of composition entered a phase of decline. The once-dynamic methodology became institutionalized as European art fell under the domination of the national academies. With the onset of Romantic painting in the early nineteenth century, the artist slowly became more independent from tradition, the academies, and public taste. This process, which continues to the present day, has always been marked by radical compositional innovations.

Impressionist Colorism

The Impressionists discovered that objects and figures do not have a single, constant appearance, but change their form and color according to the quality of light. For these artists, light is not a means to portray an object in the chiaroscuro technique. For them, light determines the color, and the color determines the form. According to Impressionist ideas, the painter should leave formulas aside and go outdoors to paint from nature and in natural light. For the Impressionists, composition was a question of colors, a problem of contrasts between tones, a search for realistic natural light. Their compositions were free of linear or structural complexities: no calculations to establish vanishing points, no spiral forms, no foreshortening or surprising viewpoints, no use of chiaroscuro. The composition is based on reality—the landscape, the figure, or the still life—as seen in the natural light of day with concrete characteristics of sun or clouds, wind or rain.

Reconceiving the Frame

The development of photography and the portable camera introduced artists to a new way of seeing reality. Photographs offered spontaneous images that probably would never have been undertaken by painters themselves. Photographers were able to take snapshots with large areas of empty space, with unusual foregrounds, or with figures and objects cut off by the margins. Painters began to understand that complex academic methods would not bring life or freshness to their works. Reconceiving the frame was enough to do the trick. In reality, this type of composition requires more sensitivity than the conventional framed picture. The painter must balance volumes, masses, and spaces that are distributed randomly on the surface of the canvas, concentrating on the visual weight of each element and not on its thematic importance.

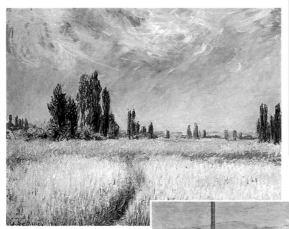

Claude Monet (1840–1926). The Wheat Field. Cleveland Museum of Art, Cleveland. Impressionist composition is based exclusively on color.

Edouard Vuillard (1886–1940). Public Gardens. Musée d'Orsay, Paris. The reconception of the frame is one of the great innovations of the Impressionists.

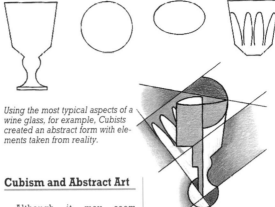

Flat Composition

Many artists of the late nineteenth and early twentieth centuries concentrated on expression through color. Some even created paintings based solely on dabs of pure color, avoiding chiaroscuro, and producing an effect near flatness. These were the *Fauves* (a French word meaning "wild ones"). Fauvism, an art movement that began in France about 1905, featured a strong, emotional use of color and decorative qualities. In Germany these artists were called Expressionists.

The fascination with color led to compositions without perspective or atmosphere. Paintings became more and more similar to designs on a flat surface, and painters sought to achieve a purely aesthetic harmony with no regard for representation. Thus, mastery of color led to experimentation in abstract art.

Using the most typical aspects of a wine glass, for example, Cubists created an abstract form with elements taken from reality.

Cubism and Abstract Art

Although it may seem strange, composition can be more easily studied in a Cubist work than in a realistic painting. This is because the Cubist's compositional lines remain visible as such. Objects are broken down into their most identifiable compositional elements

Gustav Klimt (1862–1918). Portrait of Friederike Maria Beer. Private Collection. Color and lines are combined in the flat composition typical of avant-garde art of the period.

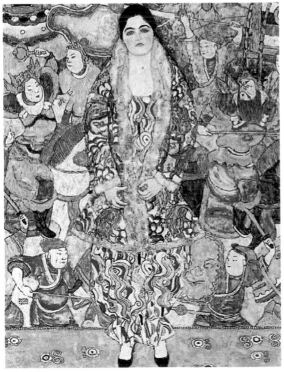

MORE INFORMATION

• Framing **p. 24**
• Colorist Painting **p. 50**

and then put back together with no regard for realism. These artists developed essentially formal compositions based on a harmonic interplay between shapes and colors that were taken from reality, but reorganized in different ways. The same principle underlies abstract art, except that abstract art does not incorporate any recognizable forms and is entirely based on the compositional interactions between pure colors and shapes.

The Cubist Compositional Method

The Cubists mentally took objects apart and separated them into their most recognizable aspects as seen from various sides. They then placed these elements in compositions chosen for aesthetic rather than representational reasons. They sought contrasts between flatness and volume, straight lines and curves, solid colors and gradations until they managed to create an aesthetic image analogous to the real object, but independent of it.

UNITY WITHIN VARIETY

Painters have always sought pictorial harmony, inventing ways of composing that would enhance the beauty of the result. At times, such methods have been widely accepted; but many artists have refused to acknowledge the existence of precise rules for achieving compositional harmony.
 Although infallible methods may not exist, the principle of unity within variety remains an essential guideline to the creation of an artistic composition with some guarantee of success.

A Universal Concept

 Greek musicians first discovered that it is possible to create harmonies by selecting notes in a perfect mathematical correlation and playing them at the same time. This is one of the secrets of musical composition. When discussing the art of painting, ancient artists differentiated between an objective, mathematical beauty (which they called *symmetry*), and a type of beauty based upon the harmonious placement of the parts (which they called *eurythmy*). The great Greek mathematician Pythagoras (c.580–c.500 B.C.) offered this definition of eurythmy: "Unity within plurality and accord within discord." From this statement it follows that artistic creation consists of finding and representing unity within diversity.

Symmetry as Unity

 The principle of unity is an essential factor in all pictorial composition. It is a method of compensating and balancing lines and forms that gives a painting stability. Symmetry and asymmetry are the two poles within which composition is developed. Complete symmetry as well as total asymmetry are extremes that generally should be avoided. Symmetry also means a perfectly stable order, which implies immobility. In fact, symmetry is the most direct and certain way to achieve a unifying effect, although this may be at the expense of visual interest.
 Symmetrical composition calls for a central axis, real or imaginary. When distributing the elements of the work, each object on one side of the axis has a counterpart on the other side. There is total equivalency and uniformity; unity is complete.
 Strict symmetry is usually based on a vertical axis, although it can also be placed on a diagonal. It is often found in primitive art and in many types of religious art. The idea associated with this pattern is that of authority and immutable order.

Asymmetry as Diversity

 Asymmetry allows greater liberty of composition. The distribution of figures and objects is freer and balance is achieved through more varied procedures. Asymmetry, which corresponds to our natural vision of the world, implies naturalism and realism. Asymmetrical works tend more towards variety, movement, and spontaneous vision. In an asymmetrical composition the importance of each element must be taken into account. Each object, small though it may be, can play a fundamental role by contributing balance, dynamism, and diversity to the final work. But an excess

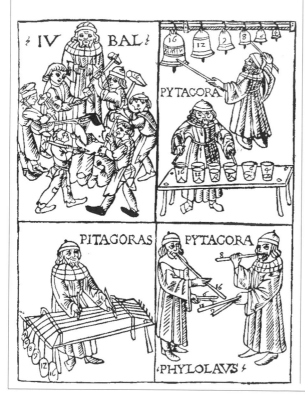

Medieval engraving illustrating the harmonic scales of Pythagorean musical theory.

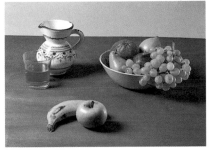

A work whose elements are grouped too closely and placed too centrally. The results are static and monotonous, caused by too much unity.

The elements of the previous composition are now placed so far apart that they do not form a unified whole.

of diversity leads to an imbalance, a scattering of elements and a generally unpleasant result. Objects should not be excessively separated from one another. That would isolate and emphasize each one of them. The viewer's attention would jump from one to the other with no transitions or common features.

A composition in which the elements are properly placed to create a balanced and unified whole.

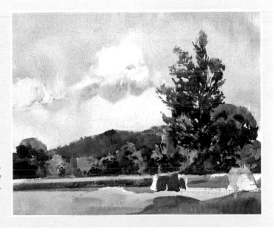

Unity within Variety

In a composition that is both unified and varied, that is to say, harmonious, the objects in the work are reasonably interrelated. They are neither grouped too closely, nor are they spread too far apart. Variety is organized within a certain order; but at the same time, each element stands out on its own. This requires alter-

nating masses and shapes, combining empty areas with groupings of objects, and slightly overlapping objects (which must not completely cover one another). An overly unified or overly dispersed composition will never be a balanced one. Thus, the principle of unity within variety relates to a work of art in which

many different elements are used in the composition and whose many different parts seem to connect well to one another.

MORE INFORMATION

• Framing **p. 24**
• Rhythm **p. 38**

Elements of Balance

Unity within variety does not depend only on the forms to be painted. Just as important is the effect of light on the objects. The type of light can be decisive. Figures should be colooted and situated according to the source of light. Shadow plays a role in the balance of the work, especially when it is produced by a direct light that defines contours.

This painting by Vicenç Ballestar illustrates the great importance of the distribution of light and shadow for the compositional balance of the work.

THE GOLDEN SECTION

The golden number or golden section comes from ancient Greece. It is a compositional aid based on mathematics. Works done with the golden section technique are innumerable. Favored by artists seeking compositional harmony and perfect balance, it was particularly common during the Italian Renaissance.

The Greek Heritage

The golden section, passed on to us by the ancient Greeks, is a system of proportions applied in a great many pictorial, architectural, and sculptural works. It was inspired by the harmonic scale developed by the philosopher and mathematician Pythagoras. His aesthetic values were renowned for their supposed correspondence with the laws of nature and of the universe. Many statistical studies have demonstrated that more works of art are based on the golden section than on any other type of measure, which suggests that many artists use it more or less intuitively. The Roman architect Vitruvius (first century B.C.) provided this definition of the golden section in one of his treatises: "In order that a space divided into equal parts be aesthetic and pleasing, the same ratio must exist between the smallest part and the largest as that between the largest and the whole."

Proportion

The great mathematician Luca Pacioli wrote a book called *De divina proportione* (The Divine Proportion), illustrated by his friend Leonardo da Vinci. In it he demonstrated that the numerical relationship of the greater segment to the smaller segment was 0.618—an approximate figure obtained through an algebraic formula. Pacioli realized that this number was the ideal measure with which to achieve unity and dynamism at the same time; in other words, it was the basis for a harmoniously correct composition. In his book, Pacioli attributes magical qualities and sublime beauty to this ratio in its artistic as well as its scientific applications. The title reflects his attitude towards the golden section as something close to God—mysterious, occult, and divine.

The Focal Point

A composition can become very complicated when using golden section divisions and subdivisions. But it is not really necessary to go so far. The rule of the golden section can be simplified by multiplying the dimensions of the canvas by 0.618. Mark the measurements obtained on either side of both the height and the width of the support, and connect each of the pairs of points. The golden point of the painting is where the two lines cross. This is where you can place the focal point of the painting, the image that will attract the attention of the viewer—the ideal point.

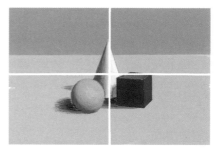

The focal point is too centered, making the composition seem static.

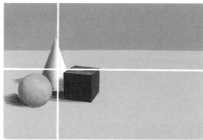

The subject is too far off center and the effect is that of imbalance.

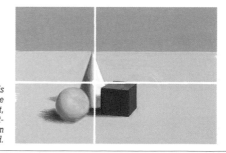

The subject is placed at the golden point, and the resulting composition is balanced.

The Golden Section Format

A format based on the golden section can be obtained by measuring one of the sides of the support (from point a to point b). Draw a square whose sides are the same as the a–b measurement. Find the middle of one of its sides by drawing the diagonals of the box, then draw a vertical line through their intersection. Place the point of a compass on the intersection of the vertical line and the bottom of the box. Extend the compass to the point indicated by the black arrow. Swing the compass as shown to obtain the new point c. The c–b distance will be the largest side of the golden section format.

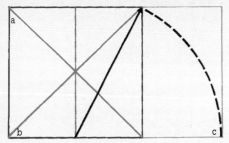

Geometrical method of obtaining a harmonious format from a given dimension (the line a–b).

Spirals

Using the golden section, it is possible to obtain other figures that can serve as a structural base for compositions. These alternate possibilities include the spiral, commonly used by artists of the Baroque period. By dividing the canvas into divisions and subdivisions using the golden section (multiply each measurement obtained successively by 0.618), an elegant spiral can be drawn that passes through the golden point of each measurement, covering the total surface area on which the painting will be done.

A Practical Resource

The law of the golden section should always be kept in mind when in doubt as to how to compose your work. The lines and points given by the golden section can resolve many aspects of the distribution of objects and figures in a composition. This rule gives the ideal proportions between the format of the painting and the objects of the composition. Applying the golden section before making a painting is a good way to solve the difficult problem of artistic composition.

But, even without making any calculations, an experienced artist can intuitively find the levels and points of the painting in which to place the most important elements: the main figure, the horizon, the most significant object, and so on.

The works done on the basis of the golden section throughout the history of art are countless. Beyond any similarities in style or period, the golden section can be seen with greater clarity in works in which compositional balance was the artist's main objective. The golden section was widely used during the Renaissance and Baroque periods. At the onset of Realism and Impressionism in the nineteenth century, painters put aside these ancient formulas to seek a more direct and personal form of expression. In the early twentieth century, avant-garde artists rediscovered the harmonic possibilities offered by the golden section as applied to abstract compositions. Today, there are many artists who continue to use the golden section to plan their compositions.

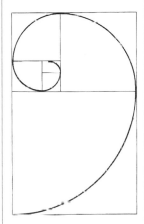

A harmonic spiral drawn by using the subdivisions of the canvas obtained with the golden section.

MORE INFORMATION

- Unity within Variety **p. 20**
- Framing **p. 24**

Vincent van Gogh (1853–1890), Wheat Field under a Stormy Sky. Rijksmuseum Van Gogh, Amsterdam. The horizon is located along a golden section line.

FRAMING

Framing a work means choosing the limits of the fragment of reality that is to be the subject. The frame takes in not only the objects portrayed in the painting, but also the space that will surround them. The shapes, spaces, and colors are chosen by the artist from the infinite variety available. The art of composition is only possible once the idea has been determined. At the time of framing, the artist draws the outlines and decides the limits of the composition.

Selecting

Framing requires artists to be receptive to what they see and to choose what might be interesting. The interpretation of the piece of reality used as the subject begins with the framing. Framing means setting borders so that no elements of the painting are left loose or in an uncertain position; it means setting up a correct composition. However, the cut-off lines of the chosen piece of reality are not transferred mechanically to the support. Framing is part of the creative process and painters can and should modify the chosen reality using their own criteria. Framing can be accomplished through exaggeration, simplification, or combining elements of what is seen. That is, framing should constitute an individual interpretation of the chosen subject according to the interests of the artist.

Distance and Format

Before deciding how to frame a work, one factor that must be considered is the distance between artist and subject. This distance should not be too great as it would make the subject too

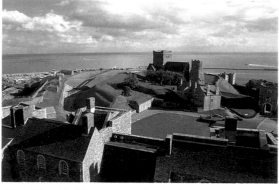

The artist must find the most appropriate framing of the subject as seen from an overall view.

small. If the distance is too short, the measurements and proportions of the subject can easily be confusing to the eye; an overview will be lacking. The artist will have to move forward toward the subject or back away from it to

find the proper framing distance. In addition, the frame is affected by the format of the support— vertical, horizontal, or square— which, in turn, is chosen according to the subject to be painted.

Preliminary Definition of the Frame

The frame is established before beginning the work and will remain essentially unchanged throughout the creative process. It provides a preview of the final results. Some artists work intensively on the preliminary composition. This leaves them free to concentrate on color and details. Careful framing, widely employed by the

This is a possible solution, but it makes the subject look too small.

This vertical framing includes too many angles and straight lines.

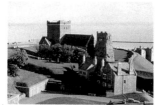

This is the most harmonious framing attempt.

This drawing is based on the previously established framing.

classical masters, was in use until the middle of the nineteenth century. Today, compositional framing lines are often very general so that they can be modified while the painting is in progress.

Simultaneous Framing

In compositions done outdoors, artists may work on the frame throughout much of the entire creative process. The effects of light and shadow need to be developed in successive sessions. Masters like Paul Cézanne (1839–1906) began at the center and moved towards the edges, thereby leaving the definitive framing until the final stage. Painting nature requires a capacity for adaptation. Details that are easily missed at first may be added as the work progresses.

Stability and Movement

The framing of a work can also affect its dynamism. A framing designed to express the stability or serenity of the subject will have its fundamental compositional lines running parallel to the sides of the painting, creating a comfortable and balanced result. A framing with oblique lines will create a sensation of movement and dynamism, if not instability. German Expressionists of the early twentieth century used the latter type of framing to intensify their passionate and disquieting view of reality.

Movement adds excitement and energy to a composition. It is a way of recording and showing action in a drawing. Movement also directs the viewer's eye through the work of art. The successful use of movement in a drawing causes it to have a feeling of strong direction.

MORE INFORMATION
- Blocking **p. 26**
- The Format **p. 32**

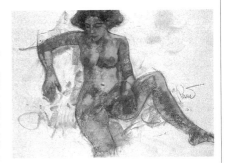

A work by Joan Raset. The figure is placed slightly off-center in a framing that makes the composition pleasant and interesting.

The Adjustable Frame

Some artists use a mechanical device to aid in framing a landscape. It is made of two L-shaped strips of cardboard put together to form an adjustable rectangle or square. By looking at a panorama through this device, it is possible to see what a particular segment of the scene may look like in the final format.

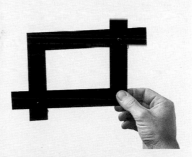

The cardboard frame is of great assistance in establishing the framing of a work because it allows you to see the effects of a composition.

BLOCKING

Blocking is a method of constructing the forms and objects in the composition. It literally consists in putting these objects into boxes or very simple schematic lines that establish the dimensions and proportions, allowing the artist to calculate the effect of the whole product. Such simplified boxes or molds are a great aid in defining the work with certainty. Geometrical shapes are an elementary tool for blocking.

Geometry

For the artist, all objects can be sketched using geometrical shapes. According to the Greek philosopher Plato, all existing bodies could be defined by ideal geometrical structures. The Platonic solids are the cube, the four-sided pyramid, the octagon (two four-sided pyramids united at the base), the dodecahedron (consisting of twelve pentagonal sides), and the icosahedron (consisting of twenty triangular sides). Most artists have applied the method of geometrical simplification as a technique for blocking. In the late nineteenth century, Cézanne revived the geometrical concepts of antiquity. He said, "...nature must be treated according to the cube, the sphere, and the cylinder." In the early twentieth century, the

Sizes and proportions can be measured using a pencil held at arm's length to check the parts of the object.

Cubists created a perfect fusion between beauty and geometry.

Blocking vs. Schematizing

Blocking is not the same as schematizing. It is obvious that looking at an object just once is not enough to retain its entire structure and details. Memory is subjective and provides a vague and often incorrect view of the object. When painting a model, careful observation is essential. Schematization can be used; that is, the model can be very roughly drawn with several loose lines. A more precise method, though, is to block in the figure using geometrical shapes.

If the form of an object is examined carefully, it will be clear that it can be reduced to basic geometrical shapes. Any object can be reduced to spheres, cubes, cones, or cylinders. Absolute geometrical precision is not necessary. A quick sketch with the correct proportions is enough.

Dimensions and Proportions

Artistic composition involves the art of drawing. Blocking is the step before the definitive sketch of the model. It consists of calculating the size and proportions of the subject and estimating how many times the height of the subject fits into its width (or vice-versa). To carry out such measurements, sighting with a pencil is traditionally used. This method consists of placing yourself in front of the subject with a pencil held in your outstretched hand. Sizes, measured by marking them on the length of the pencil with

Tangram

Tangram is an ancient Chinese game that can help you learn to draw. Any figure imaginable can be represented with its simple, puzzle-like pieces. It consists of seven small, flat wooden forms— a square, a rhomboid, and five triangles of different sizes. By trying some of the infinite possible combinations of these pieces you can get a basic idea of how to block real figures and objects. Although the pieces are flat, many combinations evoke depth or a third dimension because of the foreshortening of the model.

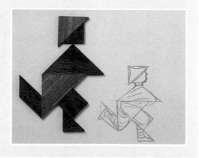

Tangram is a simple puzzle that allows you to compose figures from basic geometrical shapes.

your thumb, can be compared with other dimensions to calculate overall proportions. Once the proportions are established, you can transfer them to the canvas or paper by drawing a box, a square, a rectangle, a cube, or a regular prism, and combining flat geometrical forms with three-dimensional ones. When you are working with a single, isolated object, simple, geometrical blocking will suffice. But this is not usually the case. Generally, the subject is a still life, a landscape, or a figure. All of these require more or less complex combinations of shapes that must be transferred to the canvas.

Details and the Whole

It is essential that the artist allow him or herself to become immersed in the subject chosen. The subject itself must dictate the most adequate forms, beginning with the more general aspects and moving on to the more specific and detailed. However, not all details are important. Only those that complement or enrich the forms of the composition, those that fit well into the general scheme, should be retained.

This is very important. It is easy to fall into a copying routine—a dulling of the senses that leads to a softening of forms due to an excess of unnecessary detail. A correct balance should be achieved between the definition of the essential forms and the addition of details. The stronger the general blocking, the more details can be included.

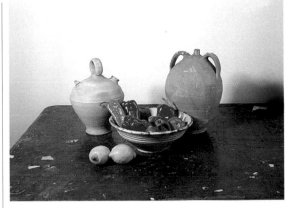

This still life can be blocked in on paper using regular shapes that place the elements in correct proportion.

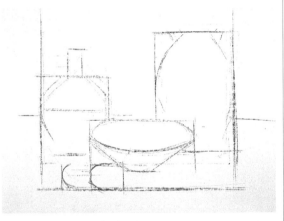

The blocking process consists in reducing the elements of, for example, a still life to simple shapes.

By working on the these simple forms and filling them out, it is possible to achieve good final results with certainty.

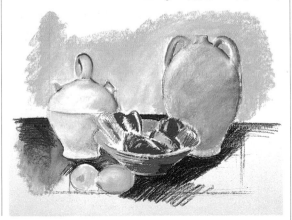

MORE INFORMATION

- Blocking and Composition: The Still Life **p. 28**
- Blocking and Composition: The Figure **p. 30**

BLOCKING AND COMPOSITION: THE STILL LIFE

When drawing a still life, study the objects carefully and calculate dimensions and proportions. The best way to block is to draw simple geometrical shapes and combine them to achieve a harmonious composition. The still life, like any other subject, can be seen as a more or less complex combination of various forms that must be transferred to the canvas.

General Blocks

The most adequate shapes to use in blocking should be dictated by the subject itself. Begin with the largest, most general elements and move on to the details.

First of all, a box or block should be established for each form or group of forms so that when the objects are drawn inside of them, the proportions are right.

The size of the boxes and of the units they represent should be in correct proportion to the format of the paper or canvas. They should be situated so that no large areas of space are left empty; and they should not take up the entire space allowed by the support. It is important to distinguish between blocking done purely for drawing purposes and pictorial blocking. In the former case, the outlines are more important because these are the only representative elements. As such, they contain all of the available information. In the latter case, color, values, light and dark areas are essential aspects; hence, a great deal of linear precision is not essential in the initial phases of the work.

> ### MORE INFORMATION
> • Blocking **p. 26**
> • Compositional Schemes **p. 34**

Contours

After the general blocking, continue working within the blocks to approximate the contours of the forms using straight lines that differentiate each one. Do this for each object or form, making sure not to be more precise on one form than on the others. The drawing should develop as a whole. Only in this way is general harmony achieved.

You can now begin to round off the straight lines used to outline the forms, ensuring that they are placed firmly on a base—that is, that they are not dangling or unbalanced. This is essential to any composition; if not resolved in the early stages of the creation process, it will be very difficult to correct in later phases.

A subject consisting of regular ovals, ideal for blocking using simple shapes.

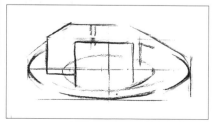

The dominant shape is the oval of the plate. The entire subject is blocked into a rectangle.

The shapes of the objects are defined by the norms established in the general blocking.

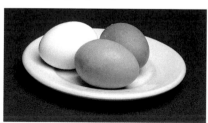

It's easy to attain the final result by fitting the shapes into the contours suggested by the blocked-in areas.

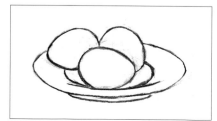

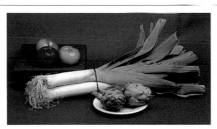

This still life also lends itself to being blocked with different basic shapes.

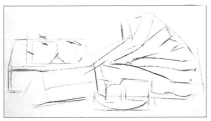

All of the elements of the still life can be blocked with approximate shapes that establish the proportions and dimensions.

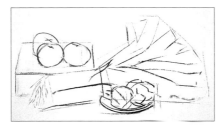

After the initial phase, the contours are slowly made more precise and the forms become rounder.

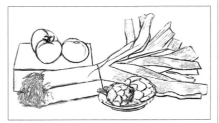

The final precision of the shapes is achieved with the aid of the preliminary lines.

Defining Contours

After approximating the contours with light lines and checking to make certain that these are accurate, use heavier lines to make the contours more precise and defined. If you find the approximating lines inaccurate, erase the errors and redo the lines. Be open to making changes in blocking the composition as the drawing progresses, to more accurately represent the basic shapes of the subject. If the proportions of the blocking are correct, defining the contours will not present a problem.

Contour lines are very descriptive. They can vary in weight and thickness and express qualities, such as softness, crispness, and boldness. They can describe the textural edges of a form or shape, as well.

Finishing the Process

Continue the process until you have completely isolated the contours of each element. You have moved from a combination of lines in which forms were barely distinguishable to a detailed grouping of clear

forms. In order to reach this end phase, the initial straight lines have been slowly transformed into smooth curves. The result is a more than satisfactory finish with which to begin the next pictorial phase. When preparing for a painting, blocking and composition can be considerably simplified because of the importance of the coloring and shading of the subject.

Composition and Geometry

Many artists have found geometry to be not only a means or an aid to obtain pictorial ends, but also an end in itself. These artists know that the regularity offered by geometry can be a source of aesthetic emotion. In fact, that emotion should be the basis for any use of geometry in a still life. In other words, the composition of a still life based on geometrical forms does not guarantee artistic quality if a sense of form and a pleasure in manipulating and combining these forms is lacking.

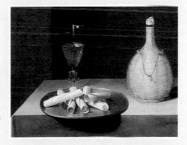

Lubin Baugin (1612–1663), The Rolled Wafer Dessert. Louvre, Paris. *A still life based on regular geometrical forms.*

THEORY AND PRACTICE

BLOCKING AND COMPOSITION: THE FIGURE

The blocking of a figure is based on the particular characteristics of its anatomy. Along with the proportions of the model, the relative size of the head with respect to the body must be kept in mind. These proportions, in turn, must be in harmony with the proportions of the support so that the figure can fit into it naturally. There are as many possible ways of blocking, but they all must establish a balanced relationship between the figure and its format.

The General Sketch

Every pose of a model suggests a sketch of the figure that can be carried out in several strokes. In fact, these could be reduced to a single continuous line; but such an extreme is not necessary. A simple shape should be selected—an oval, a polyhedron, a pyramid—but one that is rich enough to suggest the different body parts. Using this shape as well as other possible shapes that are more suited to a particular body part, the figure can be outlined with quick strokes.

Once the preliminary sketch has been made, the volumes of the figure's anatomy can be suggested. Study the sketch attentively. The initial strokes establish the position and dimensions of each part. By rounding off the angles of the sketch and accentuating the intensity of certain lines, the volumes begin to appear without having to study them separately. The drawing is a synthesis whose parts can be developed simultaneously without any one part becoming more important than another.

Modeling

Blocking is always used as a means to the artistic ends of drawing or painting. In the case of a shaded drawing, all that is needed after sketching and defining contours is to soften transitions from light to shadow. If you keep in mind that the human body is a continuous, uniform whole without abrupt changes, the sketch of the body parts will

seem natural. The presence of intense contrasts is another factor to consider in any composition of a figure. These contrasts, which can play just as important a role as the figure itself, must be calculated from the first moment of sketching.

Pictorial Sketching

A sketch done as a preliminary step for a painting should be much simpler than a sketch

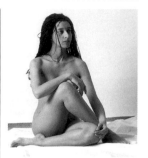

This pose suggests a triangular shape for blocking the entire figure.

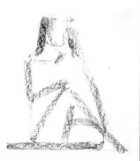

The positions of the body parts are indicated by thick charcoal lines.

Details are added once the different volumes of the figure have been correctly established.

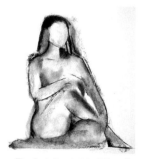

Thanks to the sketched lines, the drawing process is carried out harmoniously.

The final results—achieved by adjusting compositional factors established during the sketching phase.

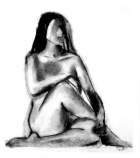

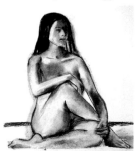

The composition of this figure involves an ordered distribution of the objects in the surrounding space.

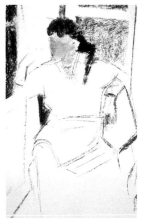

In spite of the complexity of the scene, a few quick strokes have blocked the figure and the surroundings.

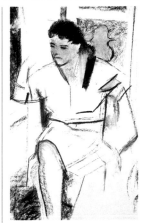

The work is based on masses of light and shadow.

done for a drawing. A drawing is actually nothing more than a fully developed sketch, whereas the sketch for a painting is done with a different intent. A preliminary sketch for a painting should leave aside all attempts at chiaroscuro or shading and concentrate on the master lines of the composition and the pose.

Figure and Format

The relationship of the figure to the format of the paper should be dynamic. This dynamism need not correspond to the movement of the figure. A static pose can be placed in a dynamic position on the support, brought about by its displacement from the axis of symmetry. Another possible way to achieve dynamism is by locating the principal masses of the figure close to the edge of the support, balancing the work by the position of the extremities or by the surrounding elements. In any case, every pose presents a different problem and must be resolved using a different balance of elements in the composition. In addition, the same pose can be sketched in many different ways, depending on the viewpoint selected by

the artist or the size of the figure on the canvas or paper.

MORE INFORMATION
• Blocking **p. 26**
• Compositional Schemes **p. 34**

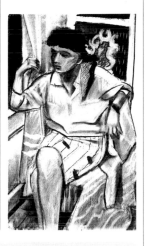

Following the parameters established in the original sketch, the drawing can be carried out in full detail

Quick Sketches

There is no better exercise in figure drawing than to do quick sketches in which only some aspects of a pose are drawn. Quick sketches can consist of only a few more or less interrelated lines with no artistic pretensions. Such nearly automatic strokes, done without thinking, suggest unprecedented possibilities for the artist. These sketches can be done on a block of paper that is best always kept at hand.

A quick sketch by Vicenç Ballestar. Using only a few, rapidly drawn lines the artist has captured the gesture and expression of the figure.

THE FORMAT

The format of a drawing or painting is determined by the dimensions and orientation of the support. In turn, the composition of the work must be adjusted to fit within the format. Although many artists have a preferred format that best suits their compositional habits, every subject should be judged separately and assigned the format that best realizes its potential. The artist uses intuition to make the correct choice or to adapt the composition to a given format.

Format as a Limiting Factor

The format of a painting sets its limits, which form part of the composition and constitute its starting point. In fact, the composition is determined first and foremost by its limits. These define the shape of the surface to be worked. All of the artist's imagination, technical skill, and sensibility will be brought to bear within these concrete limits. Creating a work on a small support has little in common with producing one for the wall of a palace or the ceiling of a cupola. The resulting composition, though it may be of the same subject, will appear substantially different in each format. When a work done in a small format is

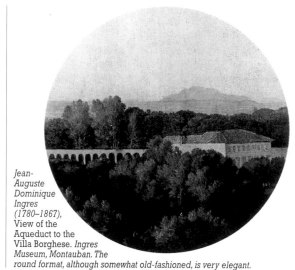

Jean-Auguste Dominique Ingres (1780–1867), View of the Aqueduct to the Villa Borghese. *Ingres Museum, Montauban. The round format, although somewhat old-fashioned, is very elegant.*

Jean-Baptiste Corot (1796–1875), Young Woman at a Well. *Kröller-Muller Museum, Otterlo. The vertical format is typical for figure painting.*

transferred to a larger format, simple enlargement is not sufficient. It will have to be modified if the expressiveness is to be preserved.

Selecting the Format

When choosing a format, the type of work to be painted must be considered. The format is not only a size, it is also the relationship between the dimensions. The format can be square, horizontal, vertical, round, elliptical, and so on. What factors will guide the artist's selection? First of all, the size desired for the work; next, the subject to be represented. Certain subjects demand a vertical format, some a horizontal one, and others are most advantageously displayed within a perfect square. These different shapes will necessarily influence the type of composition.

Albrecht Dürer (1471–1528), View of the Arno River. *Louvre, Paris. The square format favors the unity and harmony of the work. The composition, which seems quite simple, is actually rather complex.*

horizon, the seascape format is generally longer and lower than that of the landscape. For portraits and figures a vertical format is often used because it better fits the height of the face, bust, or body. These are the three classical formats: landscape, seascape, and face or figure.

Other Formats

Dimensions of canvas and watercolor or drawing paper, vary between small sketchbooks of 4 by 6 inches (about 10 × 15

Genre and Formats

The relationship between subject and format is not arbitrary. At present, there are three popular genres for which formats have virtually become standardized. These genres are the landscape, the seascape, and the figure. Landscapes almost always call for a horizontal format that is not excessively long. It is obvious that a landscape will most often be viewed as longer than it is high. Because the sea can usually be seen stretching along the

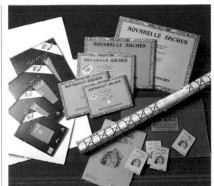

Drawing paper is always available in a wide variety of sizes, ranging from a small sketchbook to large rolls of paper.

Stretcher Sizes

In Europe prestretched canvas, or boards, and precut wooden panels, are classified with a number and a letter indicating the type of format (figure, landscape, or seascape) and a number indicating the size in centimeters. In the United States measurements for supports are designated in inches. Fine art stores everywhere will have canvases in standard sizes. These vary between 3 by 5 inches and 48 by 60 inches in the United States; in Europe, the international system is used. Although the standard formats are adequate for almost any composition, canvas can be cut and stretched to suit to any requirements.

Table of international stretcher sizes indicating figure, landscape, and seascape formats. Measurements are in centimeters.

INTERNATIONAL STRETCHER SIZES			
Nº	FIGURE	LANDSCAPE	SEASCAPE
1	22/16	22 × 14	22 × 12
2	22/19	24 × 16	24 × 14
3	27/22	27 × 19	27 × 16
4	33/24	33 × 22	33 × 19
5	35/27	35 × 24	35 × 22
6	41/33	41 × 27	41 × 24
8	46/38	46 × 33	46 × 27
10	55/46	55 × 38	55 × 33
12	61/50	61 × 46	61 × 38
15	65/54	65 × 50	65 × 46
20	73/60	73 × 54	73 × 50
25	81/65	81 × 60	81 × 54
30	92/73	92 × 65	92 × 60
40	100/81	100 × 73	100 × 65
50	116/89	116 × 81	116 × 73
60	130/97	130 × 89	130 × 81
80	146/114	146 × 97	146 × 90
100	162/130	162 × 114	162 × 97
120	195/130	195 × 114	195 × 97

cm) to large rolls that are 2 or more yards (meters) wide by 10 or more yards (meters) long. Sketchbooks measuring 9 by 12 inches (approximately 23 × 30.5 cm)—about the size of a standard sheet of typing paper—are highly portable, making them ideal for sketching or taking notes from nature. For larger formats, loose sheets are preferable. While in progress, they can be fixed to a panel; upon completion, they can be rolled or stored in a folder. Despite the fact that prestretched canvases in standard sizes are more convenient, many artists prefer to stretch their own supports. Stretcher frames with mitered, tongue and groove corners, available in a wide array of sizes, can be assembled to create canvases of almost any desired size.

MORE INFORMATION
• Framing **p. 24**

COMPOSITIONAL SCHEMES

A painting is always based on a simple compositional scheme in which all of the aspects of the subject are ordered. This rule applies whether the subject itself is extremely complex or exceedingly simple. A painter with any experience will have a tendency toward those subjects that work best with his or her manner of composing and organizing the subject on the canvas.

Centered Composition

Centered compositions provide a good example of spatial representation independent of perspective. Clearly, works in which all receding lines tend towards a central point are also centered, but not in the sense that we have in mind (the vanishing point is an abstraction, not a pictorial component). When referring to the nucleus of the composition, we mean a nearby form and not a point lost on the horizon. Therefore, perspective is not important here. In centered works, the artist defines the space by color and the distribution of forms and sizes around the compositional center. Compositional lines do not recede as in a

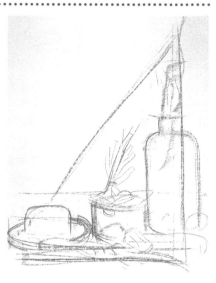

A triangular composition is combined in this work with an inverted L shape. The ordering of elements is quite solid.

The Starting Point

Compositional schemes are no more than starting points from which to begin working. During the process of creation, they must be enriched through the realism of the representation and, at times, must be modified according to new light and color relationships seen in the subject.

The centered compositional scheme of this still life, by Ana Roca Sastre, provides the perfect initial structure on which to develop the work.

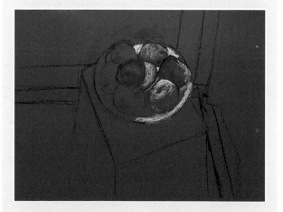

drawing in perspective. They create a surface design.

At the same time, the characteristics of the compositional center (a group of houses, some trees or animals, etc.) can be rich enough to possess a spatial aspect—that is, they can contain planes and lines that recede towards the background somewhat like a small pictorial composition. This miniature composition can be filled out with areas of color and less defined shapes that form the surroundings.

Triangular Schemes

The triangular composition is one of the most perfect since the forms are securely balanced. It can be used for a great variety of subjects and is a particularly common form for drawing the human body. It is also quite appropriate for composing still lifes with many elements. This scheme permits a balanced symmetry among the forms, all

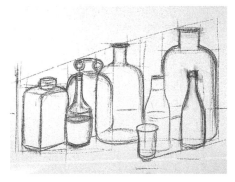

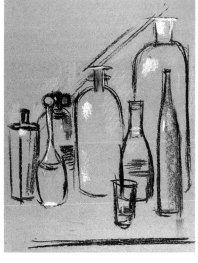

MORE INFORMATION

- Blocking **p. 26**
- Blocking and Composition: The Still Life **p. 28**
- Framing **p. 24**

*Frieze composi-
tions can include a
diagonal progres-
sion that offsets
the repetition of
elements.*

of which rest on an ample base and rise towards the top of the composition—the vertex of the triangle.

L-Shaped Composition

An L-shaped compositional scheme is applicable to any pictorial genre. It involves a horizontal distribution at the base of the painting with a strong vertical element that closes the composition on its free end. The quadrangular space above the L can be interpreted as an area in depth—a secondary space that could be developed as a counterweight to balance the fundamental motif. This space could also be developed as a completely separate ground: perhaps as a room in the background where a different scene is occurring (when dealing with interiors); or (in the case of a landscape), opening a space near the horizon into which to gaze.

Oval Composition

The balance of an oval composition is created by a denser grouping of the elements and objects of the central motif. Instead of a geometrically bal-

anced composition of counter-weights, we are dealing with a mass inscribed within an oval. It is an essentially dynamic scheme, although it is also well suited to still lifes since the round volumes of fruit and bowls can easily adapt to this space. It can also be used for landscapes, for example, by making a coastline coincide with the edges of the oval.

Frieze Composition

A frieze composition is shaped like a strip, longer than it is tall. It does quite well for still lifes, although it also often appears in landscapes based on a wide horizon. Logically, this composition is best used with horizontal formats and subjects whose elements have enough regularity of size and shape to form a string or related series when put together.

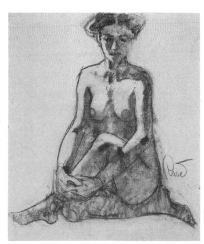

A figure placed in a centered (and, therefore, static) composition. Stability is heightened by the clearly triangular scheme.

THE SURFACE

The artistic composition is, of course, developed in a two-dimensional area on the surface of the canvas. Becoming aware of this fact is necessary before taking on a pictorial work. Whatever the type of composition may be, the artist must know how to distribute elements on the flat spaces of the support so that they demonstrate a harmony independent of the effects of perspective or depth.

The Surface of the Support

Painting means representing the three-dimensional world on a two-dimensional surface—that is, transforming reality into relations between forms and colors placed on the surface of the canvas. But these forms and colors, once transferred to the canvas, have a very different way of interacting than in the real world. If everything that the eye sees were slavishly copied, the result would be a literally accurate painting, but one that would fail to give a *true impression* of reality. The forms and colors would seem stilted, approximate, and repetitious. To succeed as a work of art, the forms and colors must have a personal quality that can be judged independently of the scene or model and which pertains exclusively to the two-dimensional composition on the canvas.

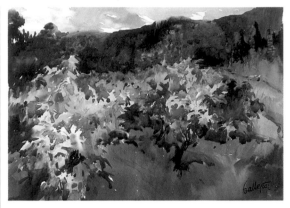

Vicenç Ballestar planned the composition of this watercolor more on the surface than in depth. However, while emphasizing color, it also suggests three-dimensionality.

Space and the Surface of the Support

The problem, therefore, is how to represent space *and* respect the surface design. Painters solutions to this problem range from perspective to chiaroscuro to Cubism. For most modern figurative painters, the Impressionist system is the most useful. Based on the chromatic unity of the canvas, it avoids the effects of chiaroscuro. Shadows are done in more faded and cooler colors than the illuminated areas, but they are not black. By using color in the shadows, the Impressionists and their followers were able to give every area of the canvas an interest of its own, independent of the subject being represented. A coloristic solution was also used to evoke distance in the represented space.

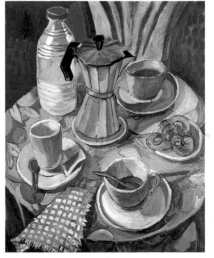

This work by Esther Olivé was composed and executed with almost total concentration on the flatness of the canvas. The forms are developed on the surface, with scarcely any intimation of depth.

Flat Forms

The solution to the problem of how to respect the plane of the canvas is to paint with flat forms and colors. But this leads directly to poster-like effects or decorative designs. Works of this type may have striking visual qualities, but they do not provide an impression of reality. All the

Using an almost monochrome palette, you can study the development of a composition on the surface.

The compositional sketch simplifies forms and covers the entire canvas.

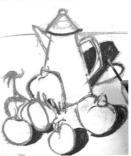

Color simply fills in the lines of the drawing, with no chiaroscuro or blending.

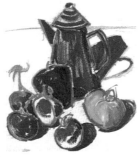

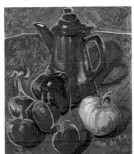

The results obtained by Esther Olivé emphasize the plane and enhance the chromatic value.

great painters have fought against this and the opposite risk—that the paintings become very realistic, but lack visual quality. The artist, therefore, must invent two-dimensional forms that at the same time can evoke a third dimension. The Cubists developed a new solution to this problem. They rejected realism to embrace the two-dimensionality of forms, but managed to suggest space and depth using halftones, blends, and dark areas that were independent of the form. At the same time, they achieved a powerful decorative quality. Visually, the whole gives a sense of depth: the objects are suspended in space, but in an abstract space—one that is pictorial, not realistic.

The Virtues of Color

If the painter works exclusively in color, the work will not fall into imitative or imprecise realism: the areas of color always refer back to the surface and come alive on it. To lend objects volume and a sense of space, shadows must be rendered in color and modeling must also be color based. The artist ignores the inexpressive unlit areas seen in the real world and transforms them into rich, dark hues, inventing tones that provide a sense of reality. This calls for truly interpreting the subject by translating all of its characteristics into pictorial values.

In a colorist work, the texture of the paint (which derives from the manner of application) further emphasizes the plane of the painting. A colorist work with rough texture and accumulations of pigment may have a remarkable visual presence and tremendous suggestive force.

MORE INFORMATION
• Compositional Schemes **p. 34**

Warm and Cool Colors

Colors can express distance in and of themselves. Certain colors advance and others recede. Warm colors always appear closer than cool colors. If the artist is aware of this fact, he or she can represent the third dimension using only color.

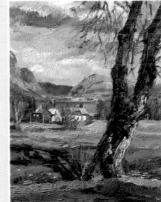

In this landscape by Miquel Ferrón, you can clearly distinguish the visual distance evoked by the cool colors (blues and mauves) of the sky and background.

RHYTHM

The rhythm of the composition is a major factor in determining the visual interest of a work. Rhythm is entirely independent of the subject and has an innate value capable of making any composition attractive, no matter how insignificant the subject. Rhythm is present in nature; the painter must be able to discover it and transfer it to the canvas.

Rhythmic Harmony

Rhythm is a rather elusive concept, difficult to define but easily perceptible in works that have it. Rhythm is present in a composition when the forms and sizes of its elements are harmonically interrelated. In nature, rhythm is found both in animate and inanimate objects—the distribution of branches or leaves around the stem, or the growth of crystals, for example. All works of primitive art possess a strong rhythm, possibly because the artists were much closer to the elementary forces of nature. In linear decorations of spears, pottery, and utensils, there is a surprising resemblance to forms found in nature (the skin of some reptiles, the nodes and buds on the stems of certain plants, and so on). Artists of genius seem to have an instinct for rhythmically ordering the forms of a painting. This rhythmic quality produces a sensation of vitality and force that can be directly associated with nature.

Combinations

The rhythm of the painting can be the product of intuition in interpreting the subject, but it can also be achieved by conscious design. All that is required is an eye for repeating masses and lines. It is, in fact, the normal process used by any artist when composing a preliminary sketch in several quick strokes. There are also more complex methods, such as subdividing the surface into areas of different sizes using the golden section or its geometrical derivatives. The important thing is that any method be a stimulus and not a brake to creativity. Intuitive thoughts must find their way into the painting without impediment and in an orderly fashion.

Trees are a perfect example of natural rhythm, painted here by Vicenç Ballestar.

This still life by Esther Olivé is based on the linear rhythms inherent in the vegetables, which provide the entire framework for the painting.

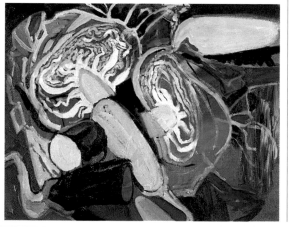

Interpretation

As a general concept, rhythmic interpretation is based on three compositional techniques: enlargement, reduction, and elimination of various aspects present in the selected subject. These aspects may concern size, color, line, shape, or light. Applying these methods depends first of all on the general impression received by the artist when viewing the subject. If it is sufficiently interesting to arrest the attention of the painter, it should be captured by emphasizing the essential aspects, reducing the secondary ones, and eliminating

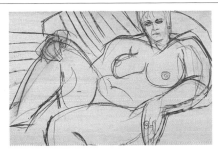

In this work by Esther Olivé, the natural rhythms of the human body are exaggerated to achieve a harmonious unity.

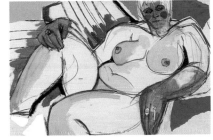

The addition of color is subordinate to the rhythmic sense of the composition.

MORE INFORMATION
- Unity within Variety **p. 20**
- Brushstrokes and Composition **p. 56**
- The Surface **p. 36**

The pictorial result is not very realistic, but this is compensated by the visual pleasure provided by the rhythmic lines.

the extra or unnecessary ones. What is essential to one painter can be superfluous to another. Experienced artists know that a finished painting is often so far removed from the reality it was based on as to be beyond recognition. The important factor is that the artist's initial emotion prevails and is transmitted to the viewer.

Rhythmic Unity

In music, rhythm is an interval of time between notes. A rhythm is said to be tiresome if it is repetitive to an extreme, without variations. The same can be said of pictorial rhythm. It needs repetition to exist: in a still life, the repetition of the shape of an object or the direction of certain lines in various places in the composition; in a landscape, the repetition of the form of a house in another, more distant or closer structure. These repetitions lend a unifying rhythm to the work. Each subject offers its own possibilities for rhythm. In a figure painting, repetitive elements must be sought; whereas in a landscape, it is often variation that must be sought to relieve the repetitiveness found in nature.

Seeking Repetitive Elements

Repeated elements can be found in any subject: curves or lines that reappear in various places, colors, similar shapes seen in different positions, and so on. The artist can enhance these repetitions so that they become stronger, thereby deepening the rhythmic quality of the work.

This landscape by Ferdinand Hodler emphasizes the similarities between mountain ridges to achieve compositional rhythm.

THE PLANE

Visually, nature does not appear flat, but the artist's job is to transfer it to chromatic (or tonal) planes (or grounds). Any artistic subject can be studied in terms of these planes, which are the compositional elements with which the painter structures a work. The contrasts between planes create a sense of space, distance, and depth.

Planes and Space

Pictorial representation is always two-dimensional, and artistic possibilities are based on this primary fact. The painter has to use procedures that allude to space without doing violence to the flat nature of the support. In reality, a painting excludes the third dimension. The pictorial purity to be found, for example, in a Medieval fresco, arises from the rejection of any spatial illusion. Nonetheless, the special expressiveness of most pictorial subjects cannot be complete without the suggestion of space. How to suggest this spatial quality through two-dimensional means?

Planes are two-dimensional surfaces and, as such, can be used pictorially. If the artist is capable of translating a perception of the subject to relations between different grounds or planes, he or she can achieve a truly pictorial embodiment of reality.

Representation through Planes

It is easy to reduce a rock to a series of facets or planes in color or shading. A tree, with its richness of shadows, details and irregularities, is more complex. A figure also presents problems, whereas the sky can be reduced to a series of precise planes. If the concept of a plane is not associated with a solid body, but rather is understood purely as a chromatic surface or area of color, then it is clear that the representation of space is possible on a two-dimensional surface. Under the ample definition of picture plane, any subject can be perfectly portrayed with a series of chromatic planes of differing intensities.

Color Areas and Three-Dimensionality

A distribution of planes or color areas always suggests space to a certain extent, even when no figurative intent exists and the planes do not represent any particular subject. Some color areas appear in front of or behind others. Some appear to be in the background, while others stand out in the middle or foreground. This is due to the contrasts among the colors, which can be of two types: a contrast in value (lighter or darker), or a contrast of hue. The painter organizes these contrasts to obtain a sensation of space. The more sensitive the artist to the distances created by these areas of color when placed in certain ways on the support, the more intense the illusion of depth. These distances will seem greater or smaller depending on the intensity of the contrast between the different planes.

Progression of Grounds

To achieve a coherent spatial effect, the different grounds must cause a receding effect, beginning with the foreground, receding through the middle areas, and terminating in the background. The richer this receding effect is, the less abrupt the contrasts will be between grounds, each of which represents a sudden jump in distance. In a panorama of a valley with gentle hills, for example, the hills softly disappear into the

This landscape by Vicenç Ballestar was begun with the plane of the sky as the background.

The furthest removed strip of land was painted next, and then the foreground.

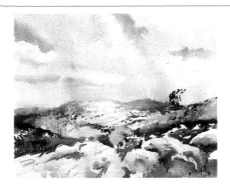

The intermediate planes have a more intense color so that they stand out (dark on light) against the background.

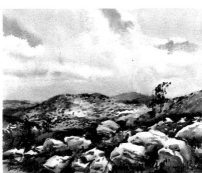

To make the rocks appear closer, the artist has created a contrast, in this case of light on dark colors.

background without any abrupt changes. The chromatic planes (paths, patches of meadows and cultivated fields, groups of trees, small houses, and so on) must maintain a continuity that allows the gaze to travel from the foreground all the way through to the furthest point of the background with no abrupt surprises. A panorama of mountain peaks, dramatic and harsh, on the other hand, calls for a series of strong contrasts or "jumps" between the grounds.

Grounds and Atmosphere

The suggestion of atmosphere in a work depends directly on the arrangement of the grounds composing it. A painting with highly contrasting grounds will lack atmosphere and will be perceived as a more or less superficial design of disparate elements. To create atmosphere, there must be some transitions between planes. Transitions are created by gradations between two grounds so that there is continuity. For example, by darkening the light tone of the foreground in the area where it borders the dark background a visual transition is obtained. Through these transitions the composition gains atmosphere. On the other hand, an excess of this type of smoothing can cause the composition to lose firmness and the forms can become blurred. As always, a balance must be reached between opposing compositional factors to achieve a satisfactory pictorial result. In any case, atmosphere and spatial depth are always related to the correct distribution and adjustment of the compositional grounds.

Seeking Contrasts

Working with chromatic planes has two pitfalls. One is the danger of overloading the work with contrasts, making it confusing and eliminating spatial continuity. The other is the danger of creating chromatic contrasts that are too subtle and languid in the fear of losing spatial continuity. In the former case, the work can have vitality that may compensate for the confusion. But in the latter, the most likely result is that the work will be insipid and lacking in visual interest. All great artists have succeeded by "betraying" their chosen subject as seen in the real world. They have had the genius to reduce it to a few contrasts or, conversely, to extend its spatial richness when the work so demanded.

The strong contrast between the foreground and the background in this work by Esther Olivé provides a clear sense of space.

MORE INFORMATION

• The Surface **p. 36**
• Lines and Masses **p. 42**
• Value Composition **p. 44**
• Colorist Painting **p. 50**

LINES AND MASSES

When preparing a linear sketch of a landscape, the artist seeks out the essential lines that underlie the subject, abstracting lights and shadows as well as individual elements and details. On the other hand, when composing a landscape by its masses, the artist views the subject as groupings of lights and shadows, which are portrayed as general volumes without lines or details.

Composition by Planes

The fundamental element of a linear composition is usually the horizon line, which separates the plane of the sky from that of the ground. Everything is organized according to the characteristics of the terrain and the position of the painter—that is, according to the point of view. The artist projects a series of simple lines and curves that define the three grounds of the landscape: foreground, middle areas, and background. There is always some element that suggests these lines: a path, the edge of a field, the banks of a river, a road. The compositional lines can also be suggested by the relations between different grounds. Thus, for example, a mountain slope and

Esther Olivé has made an eminently linear abstraction of the subject in which the important elements are the edges of the planes, some of which are highly ornamental.

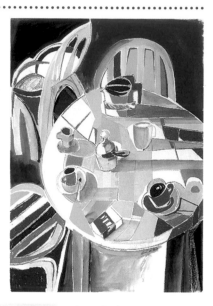

Arabesques

Arabesques are one of the most attractive options in linear composition. They consist of decorative lines that add interest and rhythm to a work. They can be found in many different objects: in the branches of a tree, in the folds of clothing, in the shapes of the clouds.

This figure by Joan Raset is developed along the arabesques of the model's pose.

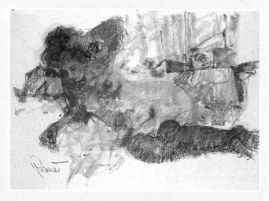

the roofs of some nearby houses can be related because they both contain the same diagonal. A curve can encompass a path as well as the tops of some trees, and so on. The meaning and purpose behind this method of composition lies in simplifying the variety of nature to create a unified whole. Using these simple lines as a base, details can be added in a clear and orderly fashion.

Composition by Masses

Another type of composition is based on the large masses of the subject, masses that can correspond to concrete elements or large areas of light and shadow. Here the term *mass* is subjective and represents the artist's visual impression. The sky can also be considered a mass in a landscape where it contrasts strongly with the color

of the ground.

This can be tested by observing a landscape with half-closed eyes. When the forms and contours lose definition, only the general aspects are visible—the lighter and darker zones. Composition by masses takes into account large blocks instead of linear aspects. A work of this type is based on the juxtaposition of a few lighter and darker areas of color grouped into more or less illuminated sectors.

Distribution of Masses

In order to organize or balance the masses or planes of a composition, a series of factors must be kept in mind: the relative sizes of the elements, the distances separating them, and the different degrees of light or darkness of each one. All of these factors are interrelated. An element important for its size, such as a large tree, can lose importance by being blended into an area of shadow. A small and distant element can become a determining factor in the balance of the composition if it is painted in a very dark, light, or bright color. Balancing the composition consists in compensating for the weight of large masses with elements that stand out because of their shape and color.

Balance does not mean immobility and total repose. It is sometimes desirable to create an imbalance to add interest and life to the composition.

Similarities and Differences

The similarity or difference between the forms of a landscape are determined by three factors: drawing, color, and volume. Two trees of very similar form in their contours can contrast through color, with one illuminated and the other in shadow. In general, the painter, when seeking unity and variety, must intensify or soften the lines, colors, and volumes of elements, although not all at the same time.

In composition by masses of color, the work is based on a general underlying tone in which contours are hardly differentiated.

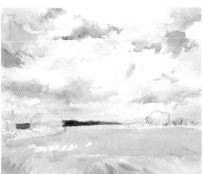

Cloud masses and the more intense color of the ground differentiate the two principal areas of the composition.

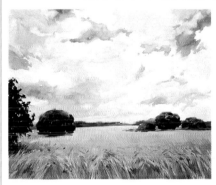

The final result obtained by Vicenç Ballestar in this painting is based on the introduction of large contrasting masses of vegetation.

Each of these factors is independent of the other. Sufficient contrast can be achieved by varying only one of them. Varying and contrasting all three at the same time will almost assuredly produce chaotic results.

A drawing often has the central function of defining contours. The more distinctive the contours, the less need there will be to differentiate them through color, which can be restricted to a discrete range of tonalities.

Color tonality is the particular selection and arrangement of color schemes, involving hue, value, and intensity relationships.

MORE INFORMATION

• Rhythm **p. 38**
• The Plane **p. 40**
• Composing a Landscape **p. 60**

VALUE COMPOSITION

Value composition is based on gradations of light and darkness. Whether you are working with one color or a limited range of colors, it is the values themselves that create the sensation of distance and provide the contrasts necessary in any successful composition.

Values and Light

Values are degrees of light and darkness. They can apply to grays (white and black are the farthest opposed values within the range of grays) as well as to colors (colors also vary in lightness and darkness). Whenever we consider light or dark areas or spots of color, we are also dealing with light; in fact, using values means working with light. The sense of brightness of a work is the product of the adequate distribution of values. Contrary to what might be expected, this sense of brightness will become more intense not if very dark tones are juxtaposed to light ones, but if there is a good distribution of intermediate value—the so-called halftones. These intermediate values make the transition from light to darkness gradual and give the work a convincingly natural air.

Esther Serra based this painting using light values on a background of dark gray.

MORE INFORMATION
• Chiaroscuro **p. 46**

New values of gray are added to the previous ones to give shape to the figure, making it identifiable.

This composition is purely value-based—that is, it is made up of the lighter and darker values of one tint of gray.

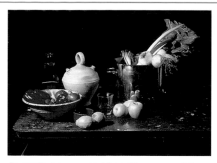

An excellent arrangement for a chiaroscuro painting.

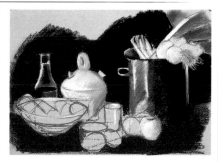

The composition is developed by limiting color contrasts in favor of chiaroscuro.

Light, Shadow, and Halftones

Whether or not atmospheric effects are desired, tonal values are indispensable in a painting. These must be balanced independently of the type of subject chosen. Rubens used a formula that he himself devised: "Two-thirds of the surface of the painting should be taken up by halftones, the other third by light and shadow." Rubens' advice is valuable not only because it was formulated by a great master of the landscape, but also because it can be observed in works from all periods. Rubens does not indicate where such lights and shadows should be located because this varies according to the subject. His formula only concerns proportions. This must be kept in mind. All experienced artists can perceive possible imbalances in the values of their works and correct them intuitively. But if they are aware of this practical principle, they can discover where the problem lies when something is wrong. That something always appears as a lack of unity; it is often due to an excess of lights and shadows (which breaks up the painting) or an excess of halftones (which weakens it).

Values and Distances

Light and dark values, whether strongly contrasted or within a gradation of halftones, aid in defining forms as well as situating them in space. To create a sense of distance, it is often enough to juxtapose a light color area with a dark one. With no further additions, these color areas appear to be located on different planes.

In any subject, the strongest contrasts occur in the foreground, whereas those in the background are softer. The painter can also use contrasts to make the more important elements of the subject stand out by placing a dark form over a lighter one, or vice-versa.

Equivalencies

Contrast of intensities can be applied to grays as well as colors. There is an equivalency between the values of grays and colors—the same type of equivalency that exists between a color photograph and a black and white shot of the same subject. When we compare them, we can see that each color corresponds to a shade of gray and that chromatic harmony depends to a large extent on the harmony of values—that is, the balance between grays, white, and black. A colorist painter must also be a good value painter in black and white.

Values and Aerial Perspective

The introduction of atmosphere, which acts as a light-filtering gauze, produces the blending present in an aerial perspective. This gradation, which is progressive and devoid of abrupt changes, is the principal cause of the sensation of depth in such a work. Many artists achieve aerial perspective through values. Others, more interested in the three-dimensional structure of the subject than in its atmosphere, nevertheless must introduce some measure of halftones into their works to obtain a realistic effect.

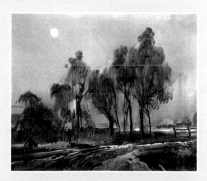

By softening contrasts between the lighter and darker values of this landscape, a harmonious sensation of aerial perspective is achieved.

CHIAROSCURO

The pattern made by light falling on objects is a key factor in creating a composition. The chiaroscuro technique assigns the leading role to the effects of light, reducing the significance of other factors such as color. The dramatic effects and plastic force of chiaroscuro make it one of the most interesting techniques of composition available to an artist.

Colorism and Value Painting

"Painters can be divided into two separate groups: those who use color to express themselves, and those who rely on the lighter or darker variations of a given hue. In the former group, we have the rainbow; in the latter, the earth colors." This distinction made by the painter and theoretician André Lothe compares colorist and value artists. Although each person has preferences, both colorism and value painting can be practiced by the same painter in different works. It would be difficult, though, to combine them in one work. Colorism and value art are almost mutually exclusive.

The Chiaroscuro Process

Composition in chiaroscuro has as its main principle the importance of modeling based on the logical development of a specific type of illumination: a single source of light affecting each object of a landscape, with a point of maximum intensity and an area of maximum darkness. This is somewhat similar to the development of a solid body illuminated laterally and modeled by the gradation of light through halftones and shadows. These ingredients can be distributed throughout the work in many different ways, but must always lie within one chromatic range.

The development of chiaroscuro begins with the strongest contrast and then moves on to soften the transition between the zones of maximum and minimum light with intermediate values. This process is continued until a coherent unity without abrupt tonal changes is achieved.

A Single Color

The painter must select (according to the subject) the basic color on which to base the chiaroscuro. Yellow, for example, could be chosen. Moving toward darker tones will lead to orange, through a range of golden browns, and then to black. Greens can be incorporated by adding a bit of black and yellow; but brilliant greens, which would break the chromatic continuity, are excluded. A cool tone should be introduced in such a warm color gradation to assist the visual transition from a warm light (yellow or orange) to a warm shadow (golden brown).

This cool tone can be simply a gray, composed of some combination of black and white. Blues, in this case, should be excluded except in small details, as should violets, which, as the complementary color to orange, would introduce a color contrast where only contrasts in value are sought. Chiaroscuro only operates around one chromatic range.

Although we have chosen yellow and orange as basic tones for our example, almost any other color can be used in a chiaroscuro composition. The most common tones are earth colors, but blues can be used for a subject requiring cooler colors.

Modeling

One of the immediate advantages of chiaroscuro is that objects can be given their maximum physical presence, making them appear truly solid and lending them a tactile quality. Modeling by saturation of color results in emphatic and highly defined volumes that are solidly set in the composition. Chiaroscuro painting means working with juxtaposed masses clearly situated in depth.

Charcoal is a medium well-suited to the chiaroscuro technique. In this work by Joan Raset, the chiaroscuro does not conceal the detail.

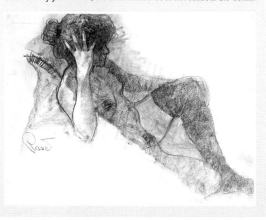

Screens and Transitions

By contrasting dark forms on light backgrounds and light forms on dark backgrounds in a screen effect, a work in chiaroscuro gains depth. Such screens are a necessary accessory to transitions from light to dark. Gradated color areas require specific points of contrast to liven them and define their extent. Contrasts of light on dark or vice-versa need not be completely solid. A dark tree on a light background needs an area in which its color lightens slowly until it blends with the background in order to fuse with it. The light background need not define the outlines of the tree perfectly, isolating it completely from the rest of the landscape. These transitions are typical of chiaroscuro compositions.

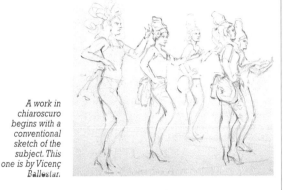

A work in chiaroscuro begins with a conventional sketch of the subject. This one is by Vicenç Ballestar.

After adding some color to the figures, the background is darkened.

The darkness of the background must not be uniform. The spatial effect resides in tonal variations.

The figures and background are done at the same time. Both must be integrated into a pictorial whole.

The results demonstrate the virtues of chiaroscuro in integrating the forms in the whole as well as in the dramatic effects of the light.

SHAPE AND COLOR RELATIONS

Shape and color are not independent factors in a composition. Changes
in size make colors appear different, so any variations in a form may also
imply variations in color. In turn, color determines the definition of the
forms. A balanced combination of the two must be achieved.

Colors and Contours

A purely linear representation of a subject can enclose each form with an entirely distinct line and capture all of the details that the artist wishes to include. Without altering the contours too much, light can also be suggested by the intensity of the lines or through shading—as long as an intense chiaroscuro is not sought. Both intense chiaroscuro and color necessarily affect the contours of objects because they emphasize some areas and hide others. When the lines defining the subject are excessively clear and precise, the colors seem false and the total effect becomes artificial. Forms appear disjointed and unrelated to one another. There is neither atmosphere nor unity. To create this unity, drawing must yield to color, which may or may not be contained within the lines defining objects.

A preliminary drawing is nothing more than a structure on which to construct light and color contrasts.

Drawing and Areas of Color

There are many theories on the relation between drawing and color, but almost all have one point in common: contours are the product of contrasts between areas of color. These areas of color can coincide more or less with the real contours of the object being painted, but the actual contours do not determine the final shape of the color. A light dab of color on a dark background produces contours—that is, a shape is created. Because natural shapes can be seen as dabs or areas of color (many artists see their surroundings in this way), color and shape can be developed at the same time. In the parts of the subject where

there are no tonal contrasts, it will be impossible to distinguish details, although that part of the landscape may actually contain trees, rocks, and so on. Artists who want to represent those details sometimes draw them linearly on the background, without giving them any special coloring of their own.

Working in this way, the painting is developed as a continuous whole in which all color corresponds to a form. In the case of a subject with zones devoid of detail, such as the water of a river or lake, or the background of the composition, the contrasts must be attenuated so that they do not produce false contours. This permits the viewer to see the surface as a continuous whole.

Simultaneous Contrast

Simultaneous contrast is a means of defining contours. It consists in lightening or darken-

This preliminary sketch by Vicenç Ballestar presents
well-defined outlines that denote the areas to be
colored.

The color of the finished work has affected certain
lines of the preliminary sketch, only following those
contours that adapted themselves to the color areas.

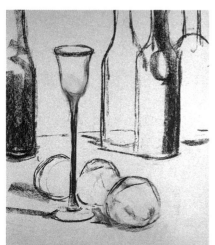

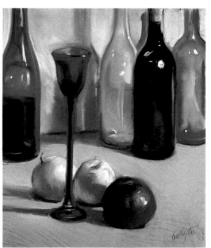

In this work by Vicenç Ballestar, the drawing only has a secondary role. The areas of color define shapes and give order to the composition.

The representation of the subject is based on color contrasts that define the contours of the drawing.

ing a color to emphasize a contour, regardless of whether this occurs in reality. For example, to emphasize a mountain ridge against the horizon, the edges of the mountain peaks can be darkened or the sky can be lightened where a clean profile is desired. By alternating these two methods along the edges of the mountains, the profile will appear natural. But if this is done mechanically, the forms will appear boxed in and isolated from one another. Therefore, simultaneous contrast should only be applied at the points where a contour should be emphasized.

The results show that color itself can define shapes with absolute independence of drawing.

Chromatic Composition

When the linear rendering does not completely define the forms, chromatic composition is necessary. This type of composition is structured on the basic characteristics of the tonality (warm or cold, earthy or atmospheric, and so on), which determine all other factors. The selection of colors should be coherent. Color can accent certain elements and reinforce relationships in a composition, as well as establish the mood of a work. Colors incongruent with the basic color range should not be included, although they may exist in the chosen subject. Many artists include colors not present in nature, but which appear completely convincing because they are in keeping with the color scheme.

Initial Tonality

Totally arbitrary use of color can lead to absurd results. To avoid such effects of incoherence, an initial tonality must be established that corresponds to the essence of the subject and to the specific sentiment that it has provoked in the artist. Working on the basis of this initial impulse and remaining true to the colors adequately expressing it, the artist can take liberties and emphasize any elements suggested by his or her sensibility.

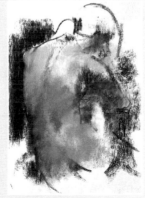

This pastel by Francesc Crespo is structured on areas of color and generic contrasts between lights and shadows. This is a preliminary step to the further development of the painting.

MORE INFORMATION

• Colorist Painting **p. 50**
• Color Harmonies (I) **p. 52**

COLORIST PAINTING

Color has laws that the painter cannot ignore. Any pictorial work must take into consideration the relations between colors, their accords and discords, and the harmonic possibilities of the different chromatic ranges.

The Mechanics of Color

All painters have color preferences—tendencies that remain more or less constant regardless of the subject being painted. These favored colors are best adapted to the artists' temperaments. With their preferred color scheme, artists can usually obtain the desired effects. Because they have experimented with colors long enough to know which combinations produce accord or discord, artists can manipulate their palettes with ease. What is known of the chromatic preferences of great painters is frequently fascinating and sometimes useful, but analysis reveals that the particular schemes are nothing more than conventional formulas. For centuries, such formulas were the only theory of color available. However, when modern science was applied to the study of light, many painters expected a universal law of color that would be independent of personal pictorial styles. Many useful insights emerged from this scientific analysis, including the distinction between primary and secondary colors and the concept of complementary colors. But a universal law was not forthcoming.

We will not discuss the theory of color in depth here because we want to concentrate on the practical side of artistic composition. But it should be noted that the theory of the colors as applied to light is not directly applicable to pigments mixed on the palette.

Any theoretical principle applied to art is more a guideline than an obligatory rule. This is all the more applicable to color theory because the use of color depends on the personal sensibility and subjective preferences of the artist.

Warm vs. Cool Colors

The warm color par excellence is orange, and all colors that are similar are also warm—including ochre yellows, earth colors tending towards orange, colors akin to burnt sienna, and the majority of reds. Many other colors can be warm as well (purples, certain greens, some pinks, and so on) depending on the surrounding tones.

The fundamental cool color is blue. Greens and purples that tend towards blue are also cool. Many other colors (various sulfurous yellows, some earth colors, etc.) can be cool as well if surrounded by warm colors.

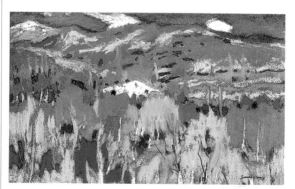

Landscape by Ramón Sanvisens based on a warm color range (oranges, earth colors, and yellows).

Landscape by Joaquim Mir based on a cool color palette (greens and blues).

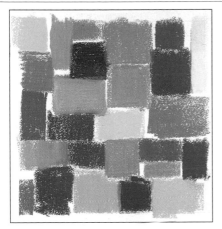

A warm color range. This range includes yellows, oranges, pinks, reds, and earth colors, with the addition of warm greens—that is, those close to yellow.

A cool color range consisting of grays, blues, greens, mauves, and cold greens.

Complementary Colors

Complementary colors are those that produce gray when mixed—though not an absolutely neutral gray, which can be obtained only by mixing white and black. The theory holds that yellow and purple are complementary, as are red and green, and orange and blue. This is true, but in painting, colors such as vermilion and cadmium red, ultramarine and azure, khaki and chrome green, are used. Such colors are not adequately covered by the theory. For example, many yellows are complements of certain blues, and many complements of red fall into the greenish blue range rather than pure green. Also, according to the theory, complementary colors enhance each other when juxtaposed. True, but only with the presence of certain intensities and quantities of them. By combining different intensities, the opposite effect can be obtained. One thing can be said with certainty: complementary colors provide the most forceful of all color contrasts.

MORE INFORMATION

• Shape and Color Relations **p. 48**
• Color Harmonies (I) **p. 52**
• Color Harmonies (II) **p. 54**

Color Perspective

It was the Impressionists, in particular Monet, who discovered that for a color to appear more distant, it need not be made grayish. It need only be made cooler, that is, bluish. Conversely, to make a color appear closer, it should be made more orange. Blue and orange are at opposite extremes of the color range. Starting with the oranges, two color groups are derived: the range from orange to yellow and from yellow to green; and the range from orange to red and from red to purple. Both arrive at blue—the former group passing through blue green; and the latter, blue violet. Oranges are not

only valid in the foreground, and blues are not restricted to the sky and the background. Both can be placed anywhere in the composition.

When considering oranges and blues, keep in mind the different shades that can be obtained through mixing.

The harmonic possibilities of the different chromatic ranges and the relations between complementary colors must be taken into consideration in any pictorial work.

Colors on the Palette

All artists distribute colors on their palettes in accordance with their personal preferences. A logical method to follow, though, is to separate warm and cool tones, organizing colors from light to dark and separating black and white.

Common distribution of oil colors on a palette. White is placed in the center or at an edge.

COLOR HARMONIES (I)

Just as every artist is familiar with the internal logic of his or her own palette, color taken as a whole also has logical patterns that pertain irrespective of the subject being painted. Although an infinite number of variations exist—as many as there are finished works—an overall pattern of chromatic sequences can be established.

Basic Chromatic Series

A well harmonized chromatic composition cannot utilize the contrast of more than one pair of complementary colors. Further, if one of the complementary colors stands out, the other should be attenuated. In chiaroscuro, the suggestion of space is created with subtle variations of intensity; in colorism, space is conveyed by the use of intermediate colors.

The basic chromatic series can be arranged in a circle whose hemispheres contain opposing pairs of complementary colors (yellow–violet, green–red) and whose poles are occupied by the pair of remaining complementary colors (blue–orange). Because of the importance of orange for nearby elements and blue for distant ones, these hue are always the basic pair in colorist

Breakdown of the two chromatic sequences that run from orange to blue.

compositions. In order to create a sensation of depth in space, most colorist painters choose one of the two possible methods: using yellow and green or red and violet. Each method also uses the contrast of the complementary colors orange–blue.

Chromatic circle as an arrangement of the colors that contrasts orange (closer to the eye) and blue (which produces a sensation of distance). Between the two we can see the red, violet, yellow, and green.

The First Chromatic Sequence

The chromatic scale that runs from orange to blue passing through yellow and green can produce bold, solid harmonies as can be seen from Cézanne's magnificent still lifes and landscapes. This sequence contains an infinite number of possibilities, yet all of them give preference to certain colors over others.

As a basic range, the artist can choose either yellow or green tones. Yellow and green are the middle colors of this scale and it is fundamental in harmony for one color to be dominant. Light ochres, creams, ivory, and a few saturated yellows are the base on which to build up a composition using this chromatic range. Such a base can be enhanced by adding darker, more intense colors from the same range. The interplay of light and dark values creates a sensation of space.

In order to clearly define the dominant warm color, sienna

MORE INFORMATION

· Colorist Painting **p. 50**

tones can be included. The more intense colors should be enhanced with gray notes so that a transition from pale yellow to burnt sienna is produced using a cool tone, thus avoiding the sickly effects produced by systematically using very warm colors to create value gradations.

Orange and Green

A strong contrast can be introduced into the basic range by using a saturated orange color. The first real chromatic contrast and the warmest, most clearly defined tone of all, it provides the visual center of the composition. This orange tone completes the warm part of the harmony. When

Chromatic sequence ranging from orange to blue and passing through yellow and green.

adding greens, the strong presence of the yellows, siennas, and ochres should be taken into account. This dominant tone should not be altered as it possesses its own harmony and softens the greens; in other words, you should not burden the harmony by confusing it with varying, intense colors that create too many chromatic contrasts. Greens, therefore, should be pale and with a bluish tendency so as

to harmonize with the cool tones that will be added later.

Grays

Some blues can be replaced by grays if the harmony of the composition calls for them. The grays tend toward the blues, enhancing the contrast with the dominant warm tones. In addition, the grays are light colors, almost identical in value to the yellow tones. Consequently, the different planes of the composition blend together harmoniously. Thanks to these grays, the blue end of the scale is suggested and introduced.

Paul Cézanne (1839–1906), Mountains in Provence. *National Museum and Gallery of Wales, Cardiff. A work painted using the yellow–green chromatic sequence.*

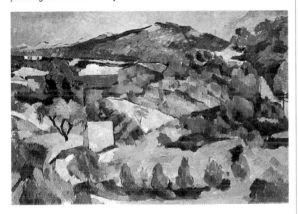

Chromatic arrangement of Cézanne's work in which the main elements of the work's dominant color sequence appear.

THEORY AND PRACTICE

COLOR HARMONIES (II)

Chevreul, the color theoretician who exercised considerable influence over the Impressionists, would frequently repeat this rule: "In order to portray the subject faithfully, it is essential that you represent what you see in a different way." The language of color is this *different way;* it translates reality into its own language—the language of chromatic sequences. The second chromatic sequence runs from orange to blue, passing through red and violet.

The Second Chromatic Sequence

When discussing the full chromatic scale, color designations are used that do not generally appear on tubes of paint. Virtually no painter uses these designations for the simple reason that they are not the names of pigments used in painting. So when we refer here to a certain range, the reader should think of the artist's colors normally associated with that range. The reds of the second chromatic sequence are closer to madder lake or burnt sienna than the magenta of the theoreticians; the painter's usual blues, ultramarine and cobalt, have little in common with the cyan mentioned in color theory; and so on.

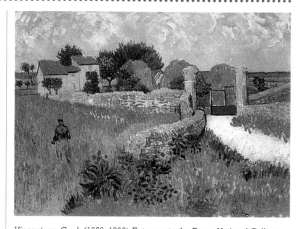

Vincent van Gogh (1853–1890), Entrance to the Farm. *National Gallery of Art, Washington. The colors of this landscape are organized using a chromatic sequence that runs from orange to blue passing through red and violet.*

Base Colors and Contrasts

The base color of the second chromatic sequence can be composed of pinks, grays, and mauves—that is, by a toned down dominant red color. More saturated tones can be added, such as stronger oranges, or a greater amount of mauve, to create the basic harmony of the composition.

The contrast between complementary colors should not be too strong. Choose light, pale tones. To intensify the harmony, it is necessary to introduce darker tones. Provided the same chromatic sequence is used, earth colors and very dark, raw

Chromatic sequence of van Gogh's landscape in which the main chromatic elements of the work's dominant color sequence appear.

Chromatic sequence that runs from orange to blue passing through red and violet.

sienna can be added—colors that can be classed as reds, but not saturated reds.

Over this color base comprising bluish grays, mauves, and pinks, a chromatic composition based on the red–violet sequence can be arranged.

The earth color is represented by different shades of red.

Blues

The complementary series of blues runs uninterrupted through the range of tones from light to dark. Only a few saturated blues have a value or intensity similar to that of the oranges. Here again, we can apply the principle that a harmonious color contrast requires reducing one of the colors of the pair to a minimum. These blues, which are the most distant colors visually, create a sensation of depth.

Color and Reality

The explanations on these pages, which refer to the harmonic potential of color ranges, may appear to stray from the basic problem of how to reproduce the colors of a real landscape. Nevertheless, the instructions offer a real way of dealing with this problem. The chromatic realism of a painting is the result of the coherence of the color relationships; being faithful to the colors seen in reality can never justify unsatisfactory combinations of tones in the painting.

Using a single subject, it is possible to experiment within the same chromatic sequence, changing the proportions of the different colors until the most suitable, or most "colorist" harmony is found.

Personal Interpretation

The idea of separating the palette into two chromatic ranges that run from orange to blue does not imply a compulsory system of proportions or relationships; it is not a recipe but a guideline for understanding the language of color. For the value painter, every object in nature possesses its own color, which becomes lighter or darker in accordance with the light. For pure colorist painters such as Cézanne and

van Gogh, every element in a subject is a possible color that must be chosen from among many others. Depending on the harmony used and the painter's intent, the chosen color may or may not be a success. Nothing has a definitive color, and the adventure of color starts afresh with every new painting.

MORE INFORMATION

• Shape and Color Relations **p. 48**
• Colorist Painting **p. 50**
• Color Harmonies (I) **p. 52**

The violets and blues of the sky culminate the chromatic sequence of this arrangement for a landscape.

BRUSHSTROKES AND COMPOSITION

By establishing the basic directions of the composition, creating rhythms, contrasting textures, and so on, the brushstroke can be a fundamental aid to composition. Composed of thick layers of paint without any smooth areas, the brushstrokes arrange and structure the color of colorist works.

The Presence of Brushstrokes

A visit to a museum that displays classical paintings is sufficient to discover the curious fact that these paintings are usually free from brushstrokes, especially if we compare them to modern paintings. This is due in part to successive layers of varnish that make the surface of the painting uniform. But most of all, it is a result of the demands of the clients who commissioned the works. However, starting with the Impressionists, the presence of brushstrokes became synonymous with modernism; the avantgarde painter had to employ visible brushstrokes, impasto, and patches of color. This opposite tendency took over, and clients came to prefer paintings with clearly visible brushwork.

Size and Direction of the Brushstrokes

The size and direction of the brushstrokes can have a considerable effect on the organization of the work. A work that uses wide brushstrokes reveals an intention to organize the objects using patches of color rather than by a gradation of values. In cases such as these, the presence of the brushstrokes in the finished work is not a mere whim but an integral part of the work; their direction and size may vary, but they could not blend together without ruining the integrity of the painting.

Other artists work on the form and color using brushstrokes that are also lines, which seek to order and arrange the objects and which, in the finished work, have left their mark on the entire

This subject calls for the composition to be treated using the direction of the brushstrokes.

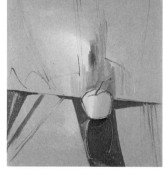

In the initial approach to this work, the main directions in which the brushstrokes will run are established.

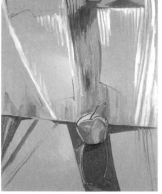

The curtains can be represented using slightly curved vertical brushstrokes that produce a sensation of transparency.

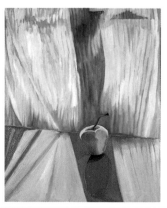

The artist Esther Olivé has achieved a work that is rich in color and perfectly composed, thanks to the marked presence of the brushwork.

surface of the canvas. This type of technique can be highly attractive for an observer interested in the painter's creative process. Because they reveal something of the artist's doubts and corrections, the brushstroke provides clues to the painter's sensitivity and intelligence.

In other pictorial styles the presence of the brushstroke is not so essential and is not based on a system; in this case, even patches of color may be alternated with lines and strokes.

Brushstrokes and Texture

Brushstrokes may serve to differentiate objects and surfaces. On the one hand, the mark of the brushwork may enliven an area of uniform color. In works such as this one, the planes of color have a different consistency and the whole gains in variety and contrast. On the other hand, brushwork may be used to unify the composition. The texture refers to the tactile quality of a surface. The clearest example of this can be seen in certain Cubist paintings in which the brushstrokes create a scaly texture that affects all the objects in the same way, thus creating a unified whole.

Calligraphy

Distinctive variations of calligraphy were developed in different regions and at various

Van Gogh's Brushwork

Van Gogh provides an extreme case of the purely constructive brushstroke used as an unalterable part of his style. In his works, van Gogh's brushstrokes not only lend color to the objects but define and model them; in other words, the form, size and direction of the brushstrokes create objects so that they adapt to the brushwork, not the other way around. In the case of van Gogh, it would be completely impossible to conceal the brushstrokes, change their direction, or alter them in any way without completely ruining the work.

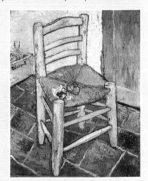

Vincent van Gogh (1853–1890), Vincent's Chair. National Gallery, London. Van Gogh's brushwork is one of the essential features of this great painter's style.

periods of time. These variations were based on the tools and the surfaces on which the calligraphy was done. The shapes of the forms are dependent on the pressure and the movement of the brush.

In many cases, the presence of the brushstroke is due to a peculiarity of the painter. These brushstrokes are not used to construct or create textures, but are a result of the painters calligraphy. The strokes may be long or short, pointillist or comma shaped, thick or thin, crisscross or parallel, and so on; they may create a rhythm or

conceal it. The presence of brushstrokes in such cases is secondary, which does not mean the work itself is a minor one, but that the artist has other means and methods of accomplishing his objectives.

MORE INFORMATION

· Rhythm p. 38
· Lines and Masses p. 42

The arrangement of the brushstrokes in this work by Esther Olivé adapts to the form and size of the objects.

In this arrangement you can see the order and direction of the brushstrokes in this work by Esther Olivé.

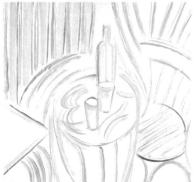

PICTORIAL PERSPECTIVE

Perspective may be applied in response to the subject. Consider, for example,
a straight path that runs into the distance in a flat landscape. In this case it is sufficient
to apply the elementary principles of geometric perspective. But in most cases the
subject is not arranged on a plane perpendicular to the plane of the painting
(a prerequisite for most representations of perspective).

Perspective and Perspectives

Linear perspective, which has enjoyed greatest acceptance among European painters since the Renaissance, is applied in all types of works. But there exist other types of perspective that adapt just as well, or even better, to certain paintings. These partial perspectives, which do not govern all the elements of the subject, give the artist a great deal of freedom. The perspective of Oriental art, for instance, is much less dogmatic and favors a looser vision of the subject, without the systematic reduction of size. In other words, it is a type of perspective that is developed more on the surface than in depth, raising the subject to the upper part of the painting instead of plunging it into the background;

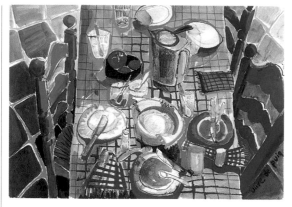

The perspective of this work by Esther Olivé is composed of different perspectives, approaching the subject from different viewpoints.

in the details of the drawing (houses, roofs, bridges, and so on), perspective serves to transform rectangles into trapezoids, very often with the shorter side pointing toward the observer (the opposite of linear perspective). We should, however, take into account that the Japanese artists did not paint from nature and felt obliged not to copy, but to use imagination.

A representation of the tablecloth in Esther Olivé's work. This part of the composition is taken from a ground view.

MORE INFORMATION
• Atmospheric Perspective **p. 64**

The tiles in this work by Esther Olivé show distorted vanishing lines.

The chairs are represented from a different point of view than the other elements in the work.

Perspective and Painting from Nature

The calculations necessary for perspective are incompatible with working from nature because the latter is based on fidelity to the artist's immediate perceptions while the former consists of the uniform application of a geometric principle. When working with the subject before you, the impression of distance usually stems more from the color than from the size, and the intensity of the colors affects the form and size of the objects. If the chromatic sensation produced by a distant object is interesting for the painter, he or she will tend to intensify it, thus giving it more importance than it would have in strictly linear perspective. But this is how the artistic sensitivity works and how the painter personalizes a creation. So, except for unusual cases, the problem of perspective does not arise when painting from nature. When it does, it can be solved by pure observation and intuition.

Tactile Values

The common experience of forms is based on both visual and tactile impressions. Objects are recognized in different positions and from different angles. When an observer moves around them,

Flat Design

The flat design of the elements of a subject, that is, representation without linear or atmospheric perspective, is unusual among modern artists. Some painters do use it when taking notes or drawing sketches in which they simply juxtapose fragments without attempting to create a sensation of depth. The results of this technique can be even more vivid than those of a finished work, precisely because it is an unconventional presentation. Space can be created by changing scale, experimenting with the sizes, and by creating a contrast between color and size.

A color note or study does not need perspective. This small work maintains a flat design, with no reference to three-dimensionality.

their appearance changes; yet the form remains stable and is still recognizable. Although the volume cannot be seen clearly, the tactile knowledge of an object is always present in the observer's awareness. All these factors, unrelated to geometric perspective, come together to represent a three-dimensional world on the flat surface of the canvas or paper. And they must be taken into account when composing a work from the viewpoint of pictorial perspective.

Vanishing Lines

Creating perspective by using several vanishing lines on the horizon suffices to lend space to a work. These lines may belong to building fronts, riverbanks, or any other feature within the subject. They may point to different vanishing points. Often, a few diagonal lines are enough to suggest the third dimension.

This landscape by Vincenç Ballestar shows a perspective suggested by the winding lines of the path. These are truly pictorial vanishing lines that do not necessarily coincide with those established in traditional geometric perspective.

Jaume Mercadé (1889–1967). The Bastion, Private Collection. The tactile values of this representation are sufficient to suggest the space without the needs for perspective.

COMPOSITION OF A LANDSCAPE

One of the features that distinguishes landscape painting from other artistic genres lies in the fluidity of the subject. A figure, a fruit bowl, a bottle, are objects that the artist can hold in his imagination and combine with other figures and objects to create arrangements in which they stand alone in an empty space to lend them greater impact. A landscape, however, lacks a definitive form because it is in constant evolution.

The Whole and Its Parts

More than in any other subject, it is the painter who shapes and explains a landscape. Throughout the history of the different styles, the landscape has been interpreted in numerous ways, in accordance with the dominant idea of nature at the time: nature as a closed off garden—isolated from the hostility and chaos beyond the mountains and woods—during the Gothic period; the idealized nature of classicism; nature as a sublime spectacle in Romanticism; nature

as a moment of light during Impressionism. Both in the major historical styles and in specific, individual styles, the landscape is based on a general idea of nature. Depending on this idea, the artist selects and stresses certain elements, shapes, or details, merely hinting at the rest (through the use of color or light and shadow, and so on). This is the basic principle in the composition of a landscape: to recreate a feeling for nature, giving priority to a limited number of features that the artist feels are significant or which appear fun-

damental to the imagined landscape. Composing a landscape signifies expressing an overall vision of nature via some of its parts.

Staggering the Planes

Another of the basic methods of developing spatial depth in a landscape is to organize it via a series of staggered planes, so that the real distances are transformed into superimposed layers. This solution is the opposite of the previous one in that the landscape does not fade into the

The landscape chosen to create different pictorial versions to illustrate the idea of staggering.

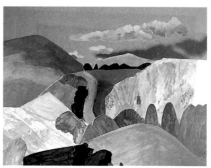

Under intense light, the planes of the landscape merge together with practically no contrast between them.

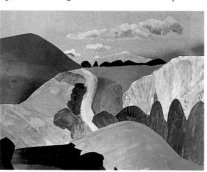

The spatial sensation becomes more intense if the light creates strong contrasts between certain planes.

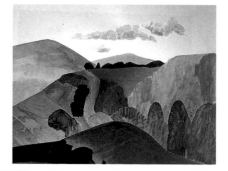

The dusk cancels out the contrasts between planes and increases the contrast between the sky and the earth.

John Sell Cotman (1782–1842), The Fallen Door. *British Museum, London. The alternating of planes is reduced to a minimum to magnify the role of the horizon.*

MORE INFORMATION
• The Horizon Line in Landscapes p. 62

different landscapes. The creative freedom of this method explains the monumental tendencies apparent in composed landscapes, their grandiose, at times epic quality.

The Horizon as a Reference Point

The horizon is one of the fundamental aspects of landscape painting and of practically all other types of figurative painting. In a still life or a scene with figures, the horizon does not usually appear, but is implicit in the composition of the work. The perspective of an object derives above all from its relationship with the horizon, a reference point that in perspective drawing is provided by the convergence of receding lines toward a vanishing point on the horizon. In landscapes this is not an ideal line but a real element. It may be defined to a greater or lesser degree, but it is always present and determines the spatial depth of the subject— something that does not usually occur in other genres where space is only shown in its most proximal planes.

distance but maintains all its detail. Sometimes, the subject itself calls for this kind of treatment, though it is usually the artist who interprets the landscape and organizes it in this way. Painters who use this technique usually prefer a solid, architectural composition rather than atmospheric effects or contrasts of light.

These staggered planes do not necessarily have to be horizontal; they can include diagonal lines, curved, and even vertical planes (a group of tree trunks, for example). In any case, these planes must be arranged so that the transition from one to the next is interpreted as a more distant plane. The scale (the larger or smaller sizes of the elements) plays an essential role in understanding space when using this method.

Selection and Combination

A composed landscape is based on selecting and combining the most significant elements of the subject, then altering their size, form, or color as required in accordance with a specific compositional and chromatic principle. This could easily be summed up by saying that a composed landscape is a free interpretation

of the subject, as in fact all landscape paintings are. Yet a composed landscape takes this interpretation even further until it becomes a deliberate exercise in free composition based on a selection of real data. This is the method followed by most classical landscape artists before the Realist and Impressionist movements of the nineteenth century; artists would paint in the studio from sketches taken from nature, combining different views of the same subject and even views of

Anatomy of a Landscape

Many landscape artists possess an almost anatomical feeling for nature. This feeling is apparent in the painting of landscapes with a topographical approach. The depressions and projections of the landscape, when interpreted emotionally, are sometimes reminiscent of the forms of the human body; the sense of plasticity and touch of a topographical landscape can be related to the painting of nudes.

Jaume Mercadé (1887–1967). A clear example of a topographical landscape in which the volumes and depressions of the terrain are emphasized.

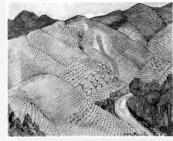

THE HORIZON LINE IN LANDSCAPES

The horizon line is of maximum importance in a composition because it determines the breadth and extension of the landscape. We refer to the horizon line in a general sense; it may be a horizontal line (in the case of the sea) or it may be formed by the irregular outline of mountains in the background; it may even disappear in the mist. In any case, it is always possible to determine the horizon line in a landscape painting.

Organizing the Space

Organizing the space in a landscape can be based on the horizon line. A low horizon line does not allow the planes to be continuously alternated; the horizon is situated close to the observer. The spatial development of a landscape with a low horizon line lies in the contrast in size between the trees, hills, and buildings. In this type of subject the sky takes on great importance, both in its color and in the form of the clouds.

A high horizon line offers the possibility of developing a subject over the entire surface of the canvas. It is usually painted from a high viewpoint, a kind of bird's eye view. It is conducive to a descriptive style that highlights each of the irregularities of the terrain, increases the number of planes, and causes the view to stretch out over a long distance. The horizon can be raised to the very top of the canvas, practically canceling the sky and creating a global sensation of nature that is more imaginative than realistic.

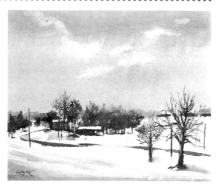

Landscape by Vicenç Ballestar in which the horizon determines the order of the composition. The position of the horizon implies a medium high point of view.

Low Horizon Line

A low horizon line implies a low point of view and a flat landscape. A landscape with a low horizon line does not allow for the alternation of planes. If the artist does so, only a few planes will separate the observer from the background of the landscape. Dutch landscape painters specialized in low horizons and flat landscapes as these are the geographical features of the Netherlands. The technique these painters used to create pictorial space was to contrast the scale and size of the elements forming the landscape; trees that are near the observer are larger than similar trees that are further away. This contrast in size is also used by the modern artist when painting works with a low horizon line. In this kind of work, it is normal that the sky should take on great importance and require special treatment.

High Horizon Line

A high horizon line allows the painter to develop the landscape over the entire surface of the paper. Painted from a high point of view, it is conducive to

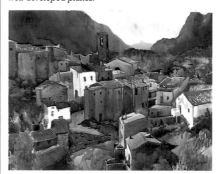

A landscape by Vicenç Ballestar with a high horizon line, painted from an elevated point of view, and with well developed planes.

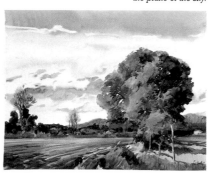

A landscape by Ballestar with a low horizon line, which emphasizes the treetops against the plane of the sky.

a descriptive style that highlights each of the irregularities of the terrain, increases the number of planes, and causes the view to stretch out over a long distance.

Some artists raise the point of view to the upper limit of the paper or even above it. In such cases the landscape tends to resemble a map, allowing the painter to cover the entire surface with different forms and colors. Distances become shorter and the work tends to appear "flattened out."

An Ambiguous Horizon

Certain modern landscape painters have experimented with the compositional and spatial aspects of the landscape genre to the point of distorting the horizon. From a theoretical viewpoint, the horizon should always be parallel to the width of the support and any sloping areas should be independent of this horizontal line. But from the creative viewpoint, it is possible to alter, deform, or distort the horizon. This can produce surprising

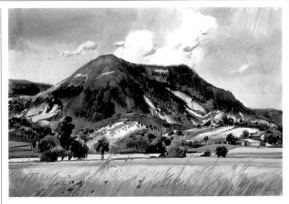

A low viewpoint of a landscape with a low horizon line are conducive to painting monumental works such as this one by Vicenç Ballestar.

results such as a sense of vertigo or the movement implied by a windy, stormy scene. This type of experiment, therefore, should not be considered a mere whim on the part of the artist, but as an attempt to increase the expressiveness of the landscape and avoid clichés.

Painting a landscape with a distorted horizon line leads the artist to deal with new compositional and spatial problems. Questioning the accepted forms can lead to truly innovative results.

MORE INFORMATION

• Composition of a Landscape **p. 60**

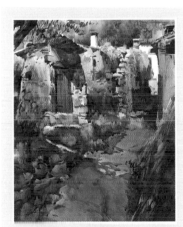

In this work by Ballestar, the vanishing point is located outside the painting. The absence of a horizon does not prevent the work from revealing a clear compositional perspective.

Horizon and Vanishing Point

It is very important for the landscape painter to have an idea, even a rough idea, of where the vanishing point lies in the painting. This knowledge can be of great help when creating a sensation of depth using a row of trees, bushes, a path, a river, and so on. Intuition is usually sufficient to situate the perspective, but on occasion it is also useful to add a few receding lines.

Sketch of the previous painting showing the implicit vanishing point.

ATMOSPHERIC PERSPECTIVE

Atmospheric (or aerial) perspective, was introduced in the West by Leonardo da Vinci. Widely employed in the Orient, this system of creating space was rarely used in ancient times and entirely forgotten during the Middle Ages. It is a phenomenon that is familiar to everyone: the fading of outlines, forms, and colors as the landscape recedes into the distance.

Depth of Field

Photographers measure the depth of field to determine the range within which objects can be held in focus. A narrow depth of field focuses only on the nearest planes; more remote planes will become hazy and out of focus. A wide depth of field can focus accurately on both the near and more distant planes. You can see this for yourself by staring at your hand raised in front of a landscape. The scene appears as a series of undefined patches of color surrounding the sharp image of you hand. When you shift your focus to the landscape, your hand becomes blurred. Our normal perception of a landscape is not like this. For exam-

This landscape is a perfect example of how the atmosphere blurs the forms and softens the outlines.

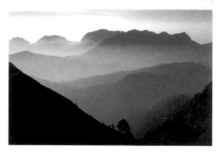

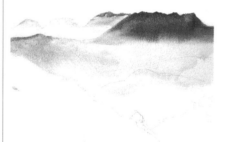

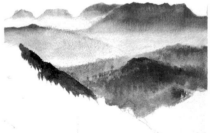

This work by Vicenç Ballestar focuses sharply on the more remote planes, which have been carefully modeled, and softens toward the foreground.

The succession of planes employs the same chromatic range, varying only in the intensity of the tones. These variations correspond to the different planes of the composition.

The darkest tones correspond to the foreground. This darkness, contrasting with the light tones of the other planes, creates the spatial effect of atmospheric perspective.

The finished work by Vicenç Ballestar is a magnificent example of atmospheric perspective.

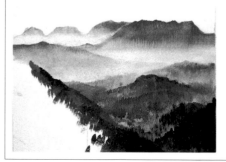

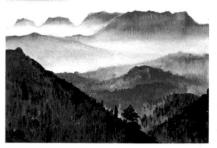

plc, when there is a group of trees in the foreground of a landscape, both trees and landscape are seen clearly because adaptations in focus are made unconsciously as our attention shifts.

Sight acts successively, not instantaneously like a photograph. It receives a series of perceptions of the different aspects of the scene, which the mind reconstructs as a whole. The type of painting that comes closest to this natural manner of seeing would be the landscapes by primitive artists who paint each detail with the same definition.

Painters give us their own particular view of space, emphasizing what they regard as the most significant elements, arranging the scene, then using color, shadows, and so on to create space. The artist creates his or her version of reality; the camera captures an instantaneous view.

Depth by Lack of Focus

Although in normal vision focusing and refocusing is done unconsciously, a fairly common method of representing spatial depth is to keep the more distant planes indistinct, and to sharpen the forms of the foreground. This method of painting is based on

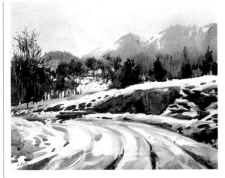

The mountains in the background of this landscape by Ballestar are blurred by the mist.

our experience that, even when we focus our attention on the most distant objects in a scene, they seem somewhat hazy because of the effects of the atmosphere. Similarly, in a painting, all objects that are blurred tend to blend and retreat into the distance, while more distinct features appear to approach the observer. Some artists achieve truly realistic effects using this method, confirming once again that it is not rigid objectivity but a coherent composition that makes a painting convincing. In this case, the technique requires transitions between the distinct and the indistinct—intermediary features that are added to make the space more readily understandable.

Chromatic Atmosphere

The prismatic colors, so called after the rainbow effect caused by the splitting of a beam of light by a glass prism, are the colors of white light: red, orange, yellow, green, blue, and violet. Atmospheric perspective, or the illusion in a work of art that objects farther away from the viewer are hazier and less distinct than objects close up, can be combined with the use of all these colors in their pure state to achieve a luminous effect that is impossible to produce in any other way. This sensation is not caused by a realistic representation of the subject, but rather by the juxtaposition of the right proportion of all the colors of the spectrum. The colors are psychologically reconstructed, rather like the physical reunification of the colors of the spectrum into white light. In other words, this method replaces the local color of objects with a combination of pure colors that are fused in the eye of the beholder.

Distance and Values

Distances in landscapes can be expressed by using contrasts of values, that is, by contrasting light and dark tones. The most obvious examples are landscapes with trees, rocks, hills, and so on in dark tones that stand out against a lighter background. The background will appear as more distant due to the contrast of values.

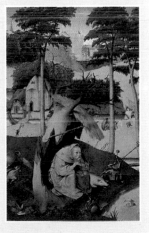

Il Bosco (1450–1516), **The Temptations of Saint Anthony,** *Prado Museum, Madrid. Quite the opposite of the atmospheric perspective is the landscape in which depth is achieved by contrasting light and dark tones.*

MORE INFORMATION
• Baroque Innovations in Composition **p. 16**

THEORY AND PRACTICE

COMPOSITIONAL SKETCHES

In the origins of a composition there is always a sketch of some kind, even if it is only a mental approximation of the overall features of the subject. Often, the artist actually makes a rough drawing before starting to paint. Sketches are also made to capture a subject seen at a glance. Whether taken from nature or an invented arrangement, a sketch is a true compositional study.

Sketches

Sketches are usually small in size and quickly drawn; they are not finished works (the background or the foreground may be missing); yet, they are complete. A sketch includes only what is necessary. It captures the essential information about the subject, not its minor details. Of course, what is deemed essential in a work depends on the vision and style of the painter. For the artist whose main interest lies in the light and atmosphere, the essential elements may be expressed with a few patches of color. For the artist seeking the solidity of volume, the sketch will be to convey the essence of the forms.

In any case, notes or sketches must be specific and are taken relatively quickly. They are not an exercise in virtuosity or detail; if one is not suitable, another is made.

An End in Itself

Notes or sketches can be a good method of practicing in

A zoo is one of the most interesting places for making a variety of sketches. They can give rise to original compositional ideas.

their own right, without any need for subsequently painting a finished work. Many artists make sketches to sharpen their powers of observation, practice their technique, and to loosen up. Sketches can be made to try out different arrangements, contrasts, groupings, and all kinds of compositional possibilities.

Sketches are also used to practice representing a subject using minimum detail. A quick, spontaneous sketch can often achieve effects that are lost during slow, painstaking work. Many interesting solutions can be found in quick sketches, solutions that the artist can later apply to more important works.

MORE INFORMATION
• Framing **p. 24**

This elementary compositional arrangement, drawn from nature, is perfectly suitable as the basis of a finished pictorial work.

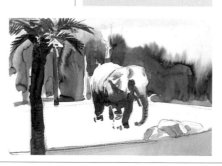

Vicenç Ballestar completes the sketch using a sepia wash that highlights the main areas of the composition.

How to Approach a Subject

Every time a painter faces a new subject, a fresh approach is required—a different deployment of the technical means, an original synthesis of the elements. This is true not only because the forms and the colors are different, but also because the experience acquired during previous works lends the artist a new viewpoint.

There is nothing better for commencing a new subject than to take notes freely and without concern for style. These notes enable the artist to overcome

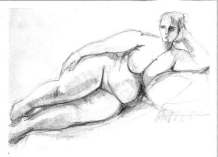

Compositional study by Esther Olivé, as preparation for a pictorial work.

This splendid sketch by Ballestar is a work in its own right, as well as a highly valuable guideline for a full-scale painting.

any fear of making mistakes and may even lead to unexpected solutions.

Studying the Composition

On occasion, the artist virtually resolves the work in a sketch that captures a definitive idea of what the finished work will be. Usually, however, the sketch or study focuses on one particular aspect—the composition, the format or framing of the subject; or

perhaps it concentrates on certain forms, the type of lighting, a range of colors, and so on.

Making sketches is particularly useful for determining the composition. A few patches of color, which may or may not faithfully represent nature, can produce an arrangement that inspires the final work. In addition, a sketch made of a specific subject may be the inspiration for the composition of a different subject or for a fragment of it.

Making Sketches While Painting

Sketches may be made after the definitive work has begun. When in doubt, which is inevitable in all pictorial work, it is advisable to try out possible solutions on a separate piece of paper before deciding which is the most suitable. There are artists who even make sketches after finishing their works to try out the new possibilities suggested by the definitive painting. There are no rules to follow; the artist has the last word.

Partial Sketches

Sketches made while working on a painting can help to solve the entire composition or a part of it. The final arrangement of complementary details can be studied using sketches of objects that did not appear in the original compositional study, but that can now be added after establishing the main lines of the work.

A Sketch-Painting

A note or sketch may go beyond a mere study and become a major element in a painting. Many artists attach great importance to their original, sketchy lines, which are retained and repeated throughout the finished work—lines that are colored, change in thickness, vary in tone, and appear to be alive. These are artists who like to combine the styles of painting and drawing. The sketch is not "colored in"; rather, it lends vitality to the colors, which spread over the original lines and create an interplay of alternating effects.

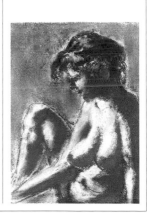

A sketch by Ramón Sanvisens, which, given the forcefulness of its realization, is actually a painting in itself.

THEORY AND PRACTICE

COMPOSITIONAL AIDS

Between the conception of a painting and the finished work, artists use a wide variety of work methods. Depending on the period, the style, and techniques employed, painters have developed many different pictorial processes. But almost all methods have had certain things in common: the preliminary sketch, compositional studies including more or less detail, and the aid of different devices and accessories.

The Grid

The grid, which is almost as old as painting itself, allows the sketch to be transferred faithfully to the canvas or paper. The artist draws a grid over the sketch and redraws it, proportionately larger in size, on the support. The contents of each square of the sketch is then transferred to the corresponding square of the emerging finished work.

This procedure is extremely useful when the artist has a drawing whose composition is satisfactory throughout. Examples taken from the history of art show that the preliminary drawing does not need to be a finished or detailed work. It is often a freely drawn sketch that the artist transfers to the canvas not because of its accuracy, but because of the freedom and spontaneity it reveals—qualities that would be difficult to achieve during the slow elaboration of a large-scale work.

It is easy to make a grid using a cardboard frame and black string. Each of the subdivisions can be reproduced to scale on canvas or paper to obtain an accurate reproduction.

The Subdivided Grid

Occasionally, a detailed design that hardly requires retouching is carefully transferred to the canvas. In order to make it as easy as possible to copy the original drawing, some painters superimpose a series of diagonal lines over the grid. This multiplies the subdivisions of the paper and provides more reference points. If the artist wishes to preserve the sketch, the grid can be drawn on a photocopy or a copy made on tracing paper.

Wire Grids

A variation on this method is to stretch wires vertically and horizontally across a frame. By studying a model through the wired frame, a gridded view of the subject can be obtained. The paper or canvas must then be divided in precisely the same proportions as the grid in order to transfer the model correctly. To make an accurate drawing, the grid should be held at a constant distance from the eye and from the subject. If this is not done, the sizes will vary each time the subject is checked.

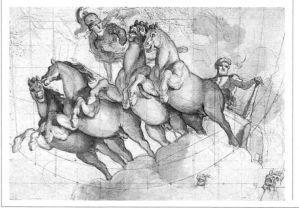

Charles le Brun (1619–1690), Apotheosis of Hercules. Louvre Museum, Paris. Using a grid to enlarge sketches into mural paintings was common among the great Renaissance and Baroque painters and decorators.

Dürer's Method

In a famous engraving, the painter and engraver Albrecht Dürer (1471–1520) represented an artist drawing a model through a large, subdivided frame. This frame is the same as the grid that some artists still use today, although greatly simplified. Like Dürer, modern artists know that the grid system produces great compositional accuracy.

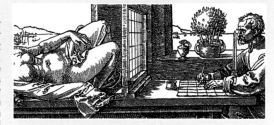

Albrecht Dürer. The grid method is revealed in every detail by this engraving.

Photography

Photography can be a magnificent auxiliary medium for pictorial composition. It is highly advisable to complement a compositional study based on sketches and notes taken from nature with photographs of the subject or model. But unless the artist wishes to create an unmistakably photographic image, it is important to remember that the photograph is merely a resource. The ideal method in the studio is to combine notes or sketches from nature with any possible modifications revealed in the photograph of the subject. Its use is also justified when it is difficult to paint the subject directly—either because the site is crowded with people, or because a fleeting scene cannot be sketched in its entirety. However, a pictorial work painted solely from a photograph tends to appear flat, losing part of the vitality and spontaneity that are achieved when working directly from nature. As with any other subject, a photograph should be interpreted from the point of view of the composition—not copied slavishly.

Versions and Variations

One possibility for achieving a good composition is to take it from another painter's work. This is what artists have done throughout history—adapting the compositions of the masters to their own needs and exploiting the balance, unity, diversity, and harmony of great works of art. This is neither to be criticized nor attributed to a lack of originality; most masterpieces take their inspiration from other paintings, and the greatest artists have always taken ideas from works they considered valuable. A highly recommendable exercise is to draw compositional schemes using great paintings—schemes that may consist merely of an arrangement of straight and curved lines using the basic divisions of the painting in question. This can suggest interesting arrangements or new possibilities for other subjects the artist has undertaken. The composition of a still life may suggest ideas for arranging the elements in a landscape, for instance, or vice versa. In any case, when reworking a masterpiece, the artist should continuously seek factors that may suggest a better solution for expressing his or her own creative originality.

> **MORE INFORMATION**
> · Compositional Sketches **p. 66**
> · Framing **p. 24**
> · Blocking **p. 26**

Using a grid in this way provides the artist with many, highly useful reference points for drawing.

By immobilizing the grid on a support and providing a reference point for the head, the artist can view the subject divided into unvarying segments. This is ideal for obtaining a highly accurate drawing.

FORESHORTENING

Foreshortening is one of the most interesting features in the composition of a figure. The technical difficulties presented are more than compensated by the dynamics it brings to the composition. Most poses involve some form of foreshortening, be it complex or simple. In certain cases, the chosen viewpoint is selected precisely because it demands a completely foreshortened composition of the figure.

Figures in Perspective

A foreshortened figure is a body whose proportions appear distorted due to the viewpoint chosen by the artist. Foreshortening is one of the typical technical problems of composing subjects with figures. Apart from this technical interest, foreshortening can be a major artistic technique if used knowledgeably and, above all, naturally.

Most poses painted by artists in compositions with figures contain some degree of foreshortening. In fact, it is difficult to find a pose that shows the entire anatomy in its true proportions. There is always an arm, a leg, a neck, or shoulder that appear foreshortened. By bearing this in mind, the artist has an additional criterion with which to choose the most suitable pose for his or her intentions.

It is important to make repeated sketches until a convincing foreshortening is obtained.

Foreshortened Legs

All seated figures that are not seen from the side show foreshortened legs. With the knees in the foreground, the thighs seem to approach the observer and appear much shorter than they really are. The artist can solve this problem while painting or experiment with different solutions to try to make the best compositional use of this foreshortening. One of these solutions is to paint a pose in which the figure is kneeling. This produces a series of curves and oval shapes as the muscles adapt to the position. These forms are a harmonious compositional subject for the artist to use in the finished work.

An Entire Body Foreshortened

An experienced figure painter knows all the anatomical forms by heart, how to block them and how to combine them in the most common poses. But when faced with a figure in perspective, all these forms are distorted. To represent the foreshortened dimensions faithfully, the artist must transmit the visual information received and forget the remembered forms. One of the most common foreshortened poses is a reclining figure observed from a high point of view. From this position, the dimensions of body parts nearest the observer seem much greater than corresponding members that are more distant. This appearance should never be altered, nor should the artist think of "correcting" them

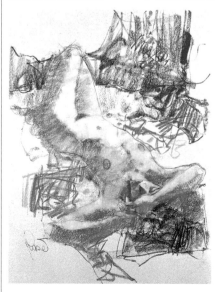

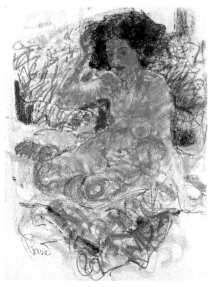

Sketch of a figure with foreshortened legs in which the linear harmony of the pose is emphasized.

Foreshortening is seeing a figure in perspective. This work by Joan Raset is a good example of foreshortening.

as these are the forms that lend compositional interest to this type of figure.

From the Front and in Profile

Foreshortening does not occur in figures seen from the front or in profile. A frontal pose, however, entails difficulties in representing the volume of the figure. Both the head and the trunk as seen from the front can be represented by a simple, flat drawing that does not convey any sense of

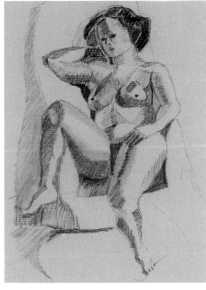

In figure seen from the front, such as this drawing by Muntsa Calbó, the internal modeling is always the dominant feature as the outlines are not sufficient to define the forms.

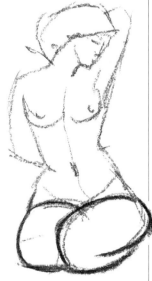

In this nude by Joan Raset, the legs of the figure are resolved in a harmonious foreshortening

their volume. The third dimension is evoked by the color and, above all, by the development of light and dark tonalities. On the other hand, a figure seen in profile can be defined by the outline. The form of the head, the facial features, shoulders, hips, and so on, can be represented by a single, continuous line. This does not mean that the color and modeling are unimportant in this type of pose; simply that these factors are secondary to the contour, which, if nimbly drawn, may be so interesting as to need only the addition of a little color. You must remember, however, that figures are rarely seen totally in profile. There are always parts of the body that are seen from the front or back.

MORE INFORMATION
· Baroque Innovations in Composition **p. 16**

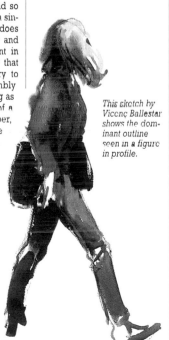

This sketch by Vicenç Ballestar shows the dominant outline seen in a figure in profile.

Technique and Subject Matter

Choosing between a figure seen from the front or the back entails a decision that involves technique as much as subject matter. Technically speaking, each of these options requires different solutions, with more or less drawing, color, or use of chiaroscuro. From the point of view of the subject matter, each pose is also different.

THEORY AND PRACTICE

THE COMPOSITION OF NUDES

The nude is one of the richest, most significant of pictorial subjects. Most of its compositional interest lies in the figure's pose and what it suggests. Although there are many possible variations, poses can be grouped and studied in several categories. This allows the artist to foresee the aesthetic effects the work will produce.

The Reclining Figure

One of the most common poses of nudes is that of a figure at rest—a classical subject that has been dealt with by painters since the Renaissance. Taking this classical pose as a starting point, the artist can create different variations to introduce novel elements to a traditional theme. One of these variations is the sleeping figure. This totally natural pose offers the possibility of developing foreshortening by choosing different viewpoints, which should not be too low.

Types of Poses

If we consider the figure as a whole composed of parts that combine harmoniously (which is how an artist should always consider this subject), a reclining pose is one in which some of the parts are emphasized with respect to the others. Once taken, the pose itself dominates the rest of the work. Expressed in terms of compositional blocking, the body can be expressed as a single mass without any external parts (an oval, rectangle, triangle, and so on; regular or irregular, but only those that are

self-contained). The completed sketch must contain more elements and more blocking, which allows the entire form and its members to be included.

Closed Pose

This type of pose is easily recognizable. The model is lying down but in a closed position—that is, with the knees bent and the legs pulled toward the body. The elbows are also bent and the arms tend to be gathered on the figure's lap. On the basic position of a closed pose, a host of imaginative and interesting variations can be made. Consequently, the subject should be studied carefully before making a decision. In addition, these poses are interesting from the aesthetic point of view, given the harmonious transition from the shoulders down to the thighs—a continuous line that adds charm to the figure.

A closed pose with a standing figure is uncommon, but worth our attention. This is a figure in a vertical, column-like position with scarcely any protrusions or irregularities. In poses such as these, the artist must be especially

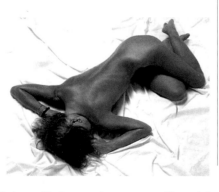

This model, lying down with the arms and legs bent, can be classified as a closed figure.

The compositional scheme of the figure can be summarized in a simple form.

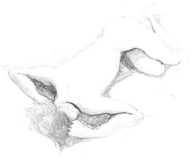

The resolution of this drawing by Muntsa Calbó has developed from the preliminary sketch.

careful to produce a harmonious outline of the entire body; it is this contour that holds all of the artistic interest.

Extended Pose

Extended poses imply movement and vitality. An extended pose usually represents an action—as opposed to a figure in repose. The history of the extended figure dates back to the origins of the genre and can be

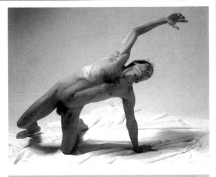

An extreme case of an extended pose that must be resolved using an open scheme.

The scheme of the pose is based on linear directions rather than on simple forms.

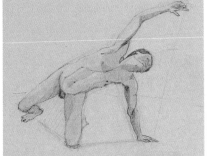

This drawing by Muntsa Calbó shows the compositional peculiarities of the figure.

MORE INFORMATION

• Blocking p. 26

traced to ancient Greek art, Egyptian art, and even cave paintings. Modern versions, characterized by their spontaneity, are a result of Impressionism and, above all, the work of Edgar Degas (1834–1917). Often, they are figures that seem to have been caught in an everyday pose. This is the essence of the open pose: capturing a natural gesture of the model.

The standing extended pose is the most dynamic of all. It clearly implies movement of the members. A point to take into account regarding this type of pose (and all types, in general) is that the movement must be justified; that is, the position of the arms and legs must match the action or specific movement and not be a mere gesture suggested by the artist to the model. If the movement has this coherence, it is

because it stems from a natural action in which the position of the legs and arms are those we would logically expect.

Realistically representing the nude, whether as a reclining figure, or in a closed or extended pose, also requires taking into account all of the variations of "flesh colors" and skin luminosity.

The Arabesque

An arabesque is a rhythmic composition based on lines that develop multiple harmonies. The nude can be interpreted in this way, using curves to define and express the anatomy. It is, above all, a linear display employing bold, wavy lines that express the anatomy while at the same time creating their own rhythm.

This pastel work by Joan Raset illustrates the idea of the arabesque. Note the intertwined, linear rhythms that define the pose adopted by the figure.

THE COLLAGE AS A COMPOSITIONAL PROCESS

The collage technique consists of pasting fragments of different materials, such as paper cutouts, fabric, and all types of smooth and rough colored surfaces, onto the support. Painted surfaces are replaced by paper, which takes on the same pictorial value as the former. In this interesting way to study composition, the ornamental and formal aspects of the arrangement take precedence over the subject matter.

The Origins of Collage

Collage was first adopted by the Cubists. By 1914, Georges Braque, Pablo Picasso, and Juan Gris, had created works with pieces of paper stuck to a support; to this they sometimes added other forms in wash or oil. There was a natural tendency for the artist to flatten the representation, avoiding all three-dimensional effects. There was also an ironic, playful note in this technique—an element that seemed to mock the usual solemnity of painting and which sought freer, more direct ways of representing objects. Modern artists are well acquainted with the collage and most of them have used it for different purposes. Collage, which is still often used ironically or as a form of research into the plasticity of the materials, can also be highly interesting for the artist interested in compositional processes.

The collage is a compositional technique that emphasizes the two-dimensional plane of the painting. This essentially flat technique is compatible with many different forms of decoration, as shown in this work by Esther Olivé.

This still life by Esther Olivé is made from paper cutouts glued and painted using the collage technique.

Decorative Color

Clearly, glued paper is an intrinsically decorative medium. The colors are entirely uniform, the contrasts they create are pure and sharp, and the result is wholly two dimensional. This type of decoration is highly suitable for murals and also for easel works. An easel work produced entirely with different collages may appear as a fragment of a mural; when alternated with other media, such as a painting using color gradations, it can create highly attractive compositions.

A still life provides the artist with the opportunity to create an interplay of decorative elements using the collage technique. Glued pieces of paper that represent, for instance, a tablecloth or

window, may alternate with a more realist treatment of the fruit or other elements contained in the composition. The contrast between unpainted surfaces—that is, those colored by the paper—and surfaces painted in accordance with the traditional techniques gives rise to highly interesting chromatic and compositional effects. Unquestionably, these can be works of art in their own right, as worthy as the artist's more traditional finished works.

Preparatory Collages

Working with newspaper cutouts, colored paper, wallpaper, and so on, is a good method for preparing and studying the composition of a still life.

A collage can also be formed with painted pieces of wood, cardboard, and so on.

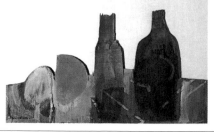

The Composition of the Nude
The Collage as a Compositional Process
Parallel Perspective
75

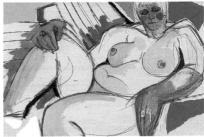

With this linear sketch, tests can be carried out using colored paper.

The combination of wallpaper and glued paper blends naturally into this composition by Esther Olivé.

By superimposing cut-out pieces of paper, the artist can form an idea of the color most suited to the subject. These studies are an excellent complement to sketches and preliminary notes on the composition. Both types of work (sketching and collages) can be utilized in the same work. By combining these preliminary tasks, the process becomes more progressive, providing the artist with a clear idea of the work before he or she starts to paint.

The Collage on Canvas

Paper cutouts can be used for many different purposes that were never thought of by the Cubists. Color swatches can be applied to plan tonal effects and color harmonies, saving yourself the trouble of making corrections later. It is always useful to have sheets or scraps of paper in dif-

Consistencies

Leather, metal, glass, cloth, fruit, wood—every one of these materials has a particular consistency that can be evoked or imitated in a work of art. Color and chiaroscuro are not the only means of suggesting the consistency of a particular material. A collage can also be rough or smooth, matte or satiny—characteristics that may suffice to convey the special qualities of the material to the observer.

ferent colors at hand so they can be used when in doubt about how to proceed. Having a wide range of colors is essential. Your uncertainty is apt to be about which tone of a particular color would be best, not whether you should use red or green. Some pieces of paper

have a special, glossy surface that is most suitable for revealing shades of color. The color may also change depending on the roughness or thickness of the paper. Using a collage in this way (that is, not as a true collage but as an experiment with colored paper) can greatly enhance your work.

MORE INFORMATION
• Blocking p. 26
• Rhythm p. 38
• The Plane p. 40

The pieces of paper are cut out and positioned in accordance with the colored areas of the composition.

The collage is a compositional technique that has its own pictorial value.

PARALLEL PERSPECTIVE

Parallel perspective is the simplest of the geometric representations of a third dimension. To understand this technique it is necessary to have a clear idea of the basic concepts that govern perspective. Concepts such as the horizon line, vanishing point, vanishing lines, picture plane, ground plane, and so on, are common to all types of perspective drawing, regardless of the complexity of the subject to be depicted.

The Horizon Line

The simplest way of conceiving the horizon line and its purpose in the representation of perspective is to imagine a person at the shore. While walking along the beach, this individual's vision encompasses a relatively

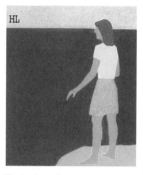

The horizon always appears at eye level. When observing the sea from an elevated point of view, the horizon line (HL) ascends, leaving a broad expanse of the water visible.

wide span of the sea and reaches all the way to the horizon, which is at eye level. If the person walks to the top of a lighthouse, a tall building, or high cliff, his or her vision will encompass a far greater span; and although the shoreline and the bathers occupy a lower level (i.e., they are further down in the visual field) the horizon line is still at eye level. Exactly the same thing occurs in perspective. The horizon is an

At beach level, the horizon line drops and the visible span of the sea narrows.

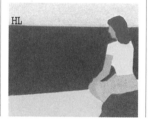

imaginary line that is exactly at the height of the observer's eyes. Other than when we are at the shore, it is rare to see a perfect horizon line in nature. But that line is always present (drawn or implied) in all types of representation in perspective.

Basic Concepts

When considering these basic concepts, we should first remember that all representation in perspective starts from the point of view (PV) of the observer, which is at the same height as the vanishing point (VP). The vanishing point is always located on the horizon line (HL) on which converge the vanishing lines (VL) of the subject. The surface on which the perspective is placed is known as the plane of the picture (PP), which, in a three-dimensional world, is an imaginary plane perpendicular to the plane on which the observer stands, called the

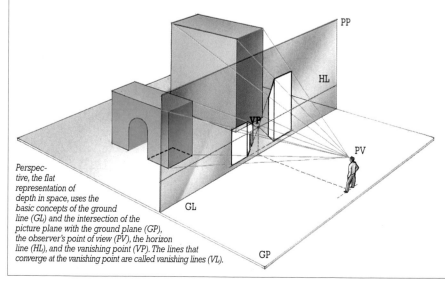

Perspective, the flat representation of depth in space, uses the basic concepts of the ground line (GL) and the intersection of the picture plane with the ground plane (GP), the observer's point of view (PV), the horizon line (HL), and the vanishing point (VP). The lines that converge at the vanishing point are called vanishing lines (VL).

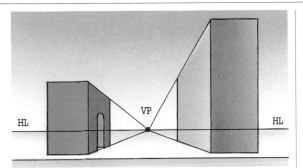

Representation in parallel perspective of the previous scheme with indications of the basic elements.

that recede until they reach the horizon. A person standing on the platform would observe how the tracks and all of the buildings parallel to them have their vanishing lines converging at the same point on the horizon.

ground plane (GP). At the intersection of the ground plane and the picture plane is the ground line (GL). Continuing in this three-dimensional world, the horizon line (HL) is the intersection of the picture plane with the visual plane at the level of the observer's sight line (PV); the distance between the ground line and the horizon line is equal to the distance between the ground and the observer's eyes.

Different Perspectives

When the point of view, which is always at the same height as the horizon, is projected onto the horizon line, it locates the vanishing point. The vanishing point is where the vanishing lines converge. In parallel perspective, the lines are parallel to each other and parallel to the ground plane. If the lines are not parallel with regard to each other, but are with regard to the ground plane, there will be more than one vanishing point on the horizon. If, on the other hand, the lines are parallel with regard to each other but not with regard to the ground plane, it is because there are different viewpoints located at different heights.

Parallel Perspective

Parallel perspective is always projected toward a single vanishing point. This occurs when the front side of the objects in the subject are parallel to the picture plane and the remaining faces perpendicular to the picture plane. The vanishing point lies exactly on the point of view—that is, it is placed at the visual center of the subject and at horizon height. A classical subject of parallel perspective is train tracks

Viewpoint and Vision

The vanishing point of any subject depends on the direction in which the observer is looking. In the real world, a clearly identifiable vanishing point would require a static, single-eyed viewer. Likewise, in the abstract world of perspective, the vanishing point implies observation from a single point—that is, with a single eye. This circumstance, among others, shows the degree of abstraction and idealization involved in the theory of perspective.

A train station in parallel perspective. The cubes summarize this type of perspective, which has a single vanishing point.

MORE INFORMATION

• The Invention of Perspective
 p. 14

ANGULAR PERSPECTIVE

Angular perspective is seen when an object has only a single edge parallel to the picture plane—that is, an object with all its faces in perspective. This form of perspective implies two vanishing points on the horizon. Using the basic notions of parallel perspective and angular perspective it is possible to construct simple figures.

Two Vanishing Points

Angular perspective is so-called because it represents objects not from the front but from the side, at an angle. In the typical case of a house, for example, parallel perspective presupposes a viewpoint on a plane parallel to the front of the house; angular perspective implies a point of view that faces one of its four corners. If in parallel perspective the side walls tended toward the same vanishing point, in angular perspective the walls situated on each side of the corner tend toward different vanishing points. In a certain sense, angular perspective involves superimposing two parallel perspectives in the same painting.

The two vanishing points remain on the horizon line, but do not coincide with the point of view, which is situated between them.

Intuitive Drawing of Parallel Perspective

Any building in perspective requires strict geometric control of the projections of the objects. But this is not how the artist works when drawing in perspective.

A representation in angular perspective indicating the two vanishing points (VP.1 and VP.2).

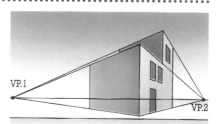

What the artist does is to trace the perspective of the object intuitively, while bearing in mind the basic concepts of geometric perspective. Making a drawing of this type is very simple. Taking a perfectly regular cube as our subject, we can begin to draw it in parallel perspective starting with the front side. Then we draw the horizon line, placing it higher the more we want to emphasize the upper face of the cube. On this horizon line we situate the vanishing point, not too far from the visual center of the cube (otherwise it would not conform to parallel perspective).

Then we draw lines from each of the four corners of the cube until they intersect at the vanishing point. The two upper lines limit the upper face of the cube. By drawing a line parallel to the upper edge of the front side of the cube and from one vanishing

line to the other (at a reasonably convincing distance), we obtain the upper face of the cube. From the intersection points of this new line with the vanishing lines, another two lines are drawn (parallel to the vertical edges of the front side), which will limit the side faces (one of which is hidden). All that remains is to draw the edge of the base (also hidden) using the intersection points with the two lower vanishing lines.

Intuitive Drawing of Angular Perspective

In order to draw a cube in angular perspective, we start with the closest edge. On the horizon line, which is raised

Cubes in angular perspective summarize the perspective view of this house.

Geometry and Reality

Intuitive constructions only make sense when the artist is observing an actual subject, draws it using the logical point of view, and maintains the correct proportions. To construct a geometrically correct cube using arbitrary dimensions (without an actual reference point), it is essential to make more painstaking projections of the object.

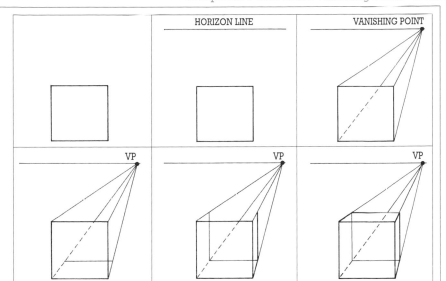

HORIZON LINE	VANISHING POINT

| VP | VP | VP |

Intuitive process of constructing a cube in parallel perspective. Starting with the front side, lines are drawn from each corner toward the vanishing point. The limits of the remaining faces are drawn on these lines.

when we wish to emphasize the upper face of the cube, there will be a vanishing point on either side of the edge. From the two ends of the edge, four vanishing lines are drawn (two toward the first vanishing point and two toward the second). On the vanishing lines on the right, a line is drawn parallel to the edge and this defines the side face of the cube; the other face is drawn in the same way using the vanishing lines on the left. From the upper corners of each of the faces, vanishing lines are drawn (toward the vanishing point on the right in the case of the left corner, and toward the vanishing point on the left in the case of the right corner). This defines the upper face of the cube. To draw the base of

the cube, the same procedure is followed. The edge necessary to complete the cube is drawn by joining the rear corners of the upper and lower faces.

MORE INFORMATION

- Parallel Perspective **p. 76**
- Errors When Drawing in Perspective **p. 82**

Intuitive process of constructing a cube in angular perspective. Starting from the closest edge, two pairs of vanishing lines are drawn on which the remaining sides of the cube are drawn.

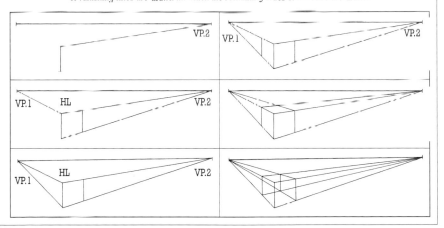

PERSPECTIVE WITH THREE VANISHING POINTS

This perspective is obtained when the object has none of its sides or edges parallel to the picture plane. Perspective with three vanishing points (or oblique perspective) means the object is tilted with respect to the picture plane, or the ground plane of the object and the picture plane do not coincide as in the aerial and the ground view.

Vertical Vanishing Lines

In both parallel and angular perspective, the vanishing lines are extensions of the horizontal lines of the object, and the vertical lines remain vertical—that is, perpendicular to the ground plane. In oblique perspective, the vanishing lines are extensions of both the horizontal and the vertical lines. Thus, this type of perspective can be considered angular perspective to which a third vanishing point has been added. This third vanishing point is situated on the second horizon line.

Second Horizon Line: Aerial and Ground View

Observing a building from the roof of another, taller building, the usual perspective in any object seen from the side is obvious; the sides retreat in angular

Perspective with three vanishing point of an arch seen from below. The vanishing points are outside the plane represented.

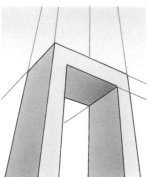

perspective toward two points situated on the horizon. But, in addition to this, the roof of the house looks larger than the base. In other words, there is a vanishing point situated outside the usual position on the horizon line. This is oblique aerial perspective with three vanishing points. A similar case occurs when a tower is observed looking up from the base; the roof of the tower appears smaller than the base and tends toward a vanishing point situated on a horizon line much higher than usual. This is oblique ground perspective with three vanishing points.

Aerial Representation of a Cube

First, draw the upper face of the cube. This should be seen in angular perspective, with its sides retreating toward two points situated on the horizon line above the upper face of the cube. This is the way to obtain the horizontal edges of the

Oblique aerial perspective of a cube showing the vanishing points (VP.1, VP.2 and VP.3), the third being situated on the second horizon line.

An aerial view showing three cubes in perspective, demonstrating the concept of perspective with three vanishing points.

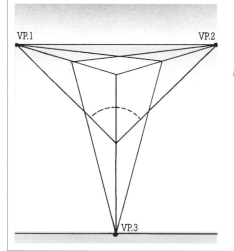

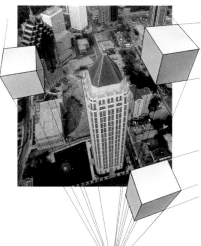

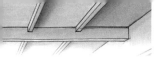

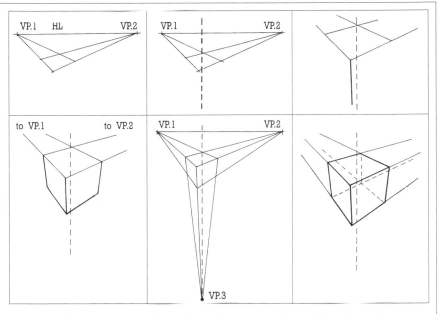

Intuitive construction of a cube seen from below showing the three vanishing points and the visual center used to situate the third point.

cube. Then the third vanishing point is added. This point should be below the cube, at its visual center; it must never occur outside the area that defines the upper face of the cube. Make the edges of the upper face converge on this point. These vanishing lines define the vertical edges of the cube. When this has been done, you have all the necessary vanishing lines for drawing from one edge to another to define the remaining faces of the cube.

Ground View of a Cube

In order to represent a ground view of a cube, all you have to do is invert the previous drawing. As examples of a cube seen from the ground with one horizon line higher and the other below the upper and lower face, consider an elevator or a crate suspended above the observer. In the case of a building seen from below, the horizon line of the horizontal lines appears to be above the base, between the upper and lower faces of the building.

Dramatic Effects

Some painters use oblique aerial or ground perspectives to achieve dramatic and visually surprising effects or striking spatial sensations in their compositions. Oblique perspectives tend to distort objects and to emphasize the contrasts between the background and foreground.

Casper David Friedrich (1774–1840). The White Cliffs of Rügen. Private Collection. A dramatic effect achieved by using a perspective with three vanishing points.

MORE INFORMATION
• Parallel Perspective p. 76
• Angular Perspective p. 78
• Perspective and Urban Landscape p. 90

In a ground view, the third vanishing point is situated on a horizon raised above the subject.

ERRORS WHEN DRAWING IN PERSPECTIVE

Drawing in perspective can lead to different errors when geometry is not taken into account or the drawing is a very rough one. Some errors are due to slips, while in other cases they are due to a lack of understanding of the laws of perspective. Geometric inaccuracy is inevitable in a freehand drawing, but mistakes due to a lack of understanding can be avoided by paying due attention to the basic principles.

Errors in Parallel Perspective

In any type of drawing in perspective, the artist must take the desired final appearance as a guide. He or she should also ascertain if the cube represented in perspective resembles a cube and if each of its faces really appears to be a square seen in perspective. In general, errors are due to the vanishing lines not converging at the same point on the horizon, thus producing a distorted figure. When drawing freehand, the error may also be that the side faces have been extended too far and appear rectangular instead of square.

Errors in Angular Perspective

In angular perspective, as the complexity increases, so does the number of possible errors. One of the most serious mistakes, which reveals poor understanding of the idea of perspective, is that the vertical edges of the cube are not parallel to each other. In angular perspective, only the horizontal edges recede and cease to be parallel, while the rest should remain parallel.

Another common error, which also shows a lack of understand-ing of the method, is when the parallel edges tend toward different vanishing points rather than converging and vanishing at the same point. A less common but more visible mistake is to draw some of the faces of the cube so that they do not appear square. This makes the object appear as a parallelepiped instead of a cube. Although the vanishing lines are accurate, if the drawing does not resemble a cube it must be corrected.

Another common mistake occurs when the cube appears to be distorted, as if seen in perspective with three viewpoints, yet the vertical edges do not meet at the same vanishing point. This problem, which may occur even when the artist has a good understanding of perspective, indicates that the cube was not situated correctly in relation to the horizon line and the vanishing points. The fault usually lies in the angle formed by the side faces of the cube. The faces form an angle of exactly 90°, so the angle in a drawing cannot be less than 90°. To prevent this mistake, you must not draw the two points of view close together, nor situate the cube too far below the horizon line. Above all, you should make sure that the angle is 90°.

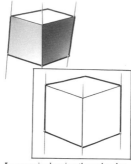

An error in drawing the cube due to the lack of parallelism between the edges.

Real Subjects and Distortions

It is essential to have a clear idea of the principles of drawing in perspective in order to spot possible mistakes made when drawing from nature. But it is, perhaps, even more important to pay attention to the form and configuration of the real perspective, which is usually composed of highly irregular forms that do not allow the artist to check them geometrically.

Errors in Perspectives with Three Vanishing Points

These errors usually occur when the upper face of the cube (the typical example) is not well drawn. This face should appear

One of the most common mistakes in intuitively drawing a cube is to situate the rear face too far from the front face.

MORE INFORMATION

- Parallel Perspective **p. 76**
- Angular Perspective **p. 78**
- The Perspective of Regular Volumes **p. 84**

as if it were drawn in angular perspective, with the only difference being that the viewpoint is situated very low (ground view) or very high (aerial view). The artist must take into account that perspective with three vanishing points is the one that most distorts the forms. Consequently, when drawn freehand without carefully calculating the vanishing lines, mistakes are most likely to occur.

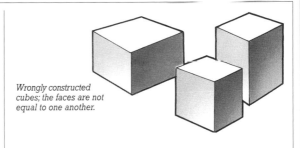

Wrongly constructed cubes; the faces are not equal to one another.

Errors and Freehand Drawing

The accuracy of a drawing in perspective executed with the aid of rulers cannot be equaled when drawing freehand. But the mistakes mentioned in this chapter are not slips in accuracy; they are the result of an erroneous idea. An artist who has a clear understanding of the basic principles that govern drawing in perspective will not make mistakes of this kind. These mistakes are immediately visible in any sketch, regardless of the straightness of the lines. Artists who use perspective in their works must take these factors into account so that the result will not contain serious distortions or impossible views of the elements forming the composition. Once these conceptual errors have been corrected, it does not matter too much if the lines of a freehand drawing are not entirely accurate. In pictorial work, geometric precision is not as highly valued as a correct arrangement of the different volumes in the compositional space.

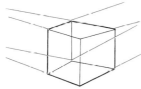

An error in the construction of a cube in angular perspective due to the failure of some of the pairs of vanishing lines to converge.

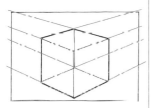

An error in the construction of a cube in angular perspective due to vanishing lines that are parallel to each other.

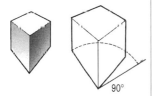

This cube illustrates an incorrect angle of the faces, which can never be less than 90°.

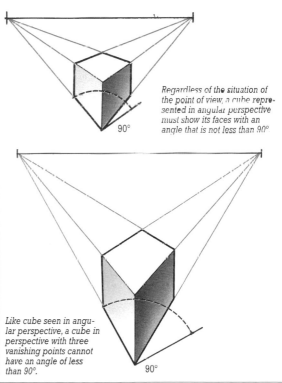

90°

Regardless of the situation of the point of view, a cube represented in angular perspective must show its faces with an angle that is not less than 90°

90°

Like cube seen in angular perspective, a cube in perspective with three vanishing points cannot have an angle of less than 90°.

90°

THE PERSPECTIVE OF REGULAR VOLUMES

Many real forms can be summarized by using regular volumes. Knowing how to draw forms in perspective also means being able to project the perspective of regular volumes. These are really simple applications of the basic principles of parallel and angular perspective, with slight modifications in each case.

Perspective of a Circle

A circle is a flat surface surrounded by a circumference. It is a surface that occurs in many objects—glasses, cups, plates, and several different containers. If you know how to draw in perspective, you can draw all of these and many other forms.

A rough circle can be drawn freehand by inscribing it within a square. First, draw the square, its diagonals, and a cross to provide as many references points as possible for the drawing. Then,

each half of the diagonal lines is divided in three parts and a square is drawn that has as its vertices the outer subdivisions. With this new square, there are a total of eight reference points for drawing the circle.

To draw a circle in parallel or angular perspective, first the square is drawn in perspective (with the entire system of diagonal lines, a cross, and an inner square). Then an ellipse is drawn (a circle in perspective resembles an ellipse) by joining the reference points in exactly the

Errors when drawing a circle in perspective, due to a poorly drawn square in perspective.

same manner as in the previous drawing.

A Cylinder in Perspective

A cylinder is a geometric form whose upper and lower faces are circles.

To draw a cylinder in perspective, it is only necessary to know how to draw circles and regular prisms (cubes with elongated sides). Imagine that the cylinder is contained within a prism. After drawing the prism in perspective, circles are drawn for the upper and lower faces following the procedure described above.

Errors When Drawing Circles and Cylinders

The first thing to bear in mind is that a circle in parallel or angular perspective is always a perfect ellipse; if it does not

A simple method for drawing a circle starting with a square. After drawing the diagonal lines, a second square is drawn a third of the distance from the center. This results in eight reference points for drawing the circle freehand.

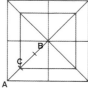

A method for drawing a circle in perspective using a square in parallel perspective subdivided in the same way as in the previous exercise.

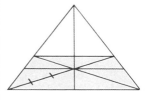

How to construct a cylinder starting with a rectangular parallelepiped in parallel perspective.

MORE INFORMATION
• Parallel Perspective **p. 76**
• Angular Perspective **p. 78**

resemble one, there is some mistake in the drawing. The error may be due, for example, to the fact the angle in the nearest corner of the square on which the circle is inscribed is not (as it should be) less than 90°. It may be that the ellipse has been constructed using lines that are not sufficiently curved. Or the reference square may be slightly rectangular, making the circle in perspective look more like an oval than an ellipse.

With cylinders, the artist should ensure that the circle in perspective that forms the base does not have any straight edges where the curve of the circle meets the sides of the cylinder.

Pyramids and Cones

In order to represent a cone in perspective, draw the perspective of an appropriate parallelepiped; inscribe a circle in perspective inside the base; and draw a line that rises from its center to the center of the upper face. Join this point with the lower face via two lines that are tangential to the circle, taking care to round off the points where they meet.

The same procedure is used to draw pyramids in perspective. Drawing a pyramid in perspective is based on the perspective of the base (a triangle, a square, or any other figure). Complex forms can be achieved by containing them in a square, as is done to obtain a circle. Once this form has been drawn in perspective, all that is necessary is to determine the height, locate the vertex, and draw in the remaining lines of the figure.

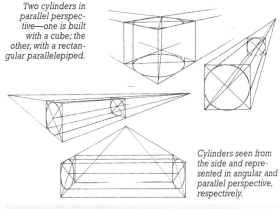

Two cylinders in parallel perspective—one is built with a cube; the other, with a rectangular parallelepiped.

Cylinders seen from the side and represented in angular and parallel perspective, respectively.

The Perspective of the Sphere

A sphere is an unusual figure; when seen in perspective, its aspect does not vary in the slightest. If a spherical object has ornaments on its surface, these are usually situated around the perimeter of a circle in perspective contained within the sphere. Draw the circle using the method described above.

Spheres maintain the same form from any viewpoint; the only features that can appear in perspective are any decorative motifs or details they may possess.

The construction of a pyramid using a regular parallelepiped.

The construction of a six-faced pyramid using a hexagonal parallelepiped, which, in turn, can be obtained using a rectangular parallelepiped in perspective.

The construction of two cones using two different parallelepiped in perspective.

THE DIVISION OF PLANES INTO EQUAL PARTS IN PARALLEL PERSPECTIVE

The true usefulness of perspective lies in the possibility of calculating reductions in size due to the distance; in other words, the possibility of placing different forms within a coherent whole. If the method for subdividing spaces in perspective is used, it is easy to calculate and represent these reductions in size.

Dividing an Undetermined Space into Equal Parts

If we imagine any space drawn in parallel perspective—a railroad track, for example—we face the problem of how to draw the cross ties and what distances to establish between them so that it really looks as if they stretch out between the rails. It is basically a question of dividing a space in perspective into equal parts.

The method is very simple. With the horizontal space in parallel perspective (two vanishing lines that run from the base of the drawing to the vanishing point), draw a third line from the center of the same base to the vanishing point. Then draw the first cross tie at a natural distance from the base of the drawing. Draw a diag-

onal line running from the base of one of the vanishing lines to the point of intersection between the cross tie and the central dividing line. Extend this diagonal line until it cuts the second vanishing line to obtain the point that marks the distance from the second cross tie. By repeating this operation, you can draw all the cross ties, dividing the line into equal spaces when seen in perspective.

Dividing a Definite Vertical Space into Equal Parts

The previous system is useful for dividing an indefinite space into an equally indefinite number of equal sections. When we need to divide a plane into a

given number of parts, we have to use the *measuring line* method. The measuring line is a straight horizontal line that should be situated just at the height of the lower point of the front edge of the plane to be divided. The intersection between the front edge of the plane and the horizon line is called the *measuring point*. By drawing a line from the measuring point to the lower point of the rear edge until it cuts the measuring line, we obtain a segment that is to be divided into an equal number of partitions. When these partitions have been made, they are transferred to the plane in perspective, extending each of them toward the measuring point. Each extension will cut the baseline of the plane at the point where it should be divided.

(a) *To divide a space into equal parts of an undetermined size in parallel perspective, we begin by defining the initial width and extend it in perspective.*
(b) *Then we established a distance (point B) and a line is drawn parallel to the base. Where this line cuts the vanishing line that runs from the center of the segment of the vanishing point, a diagonal line is drawn between this point and A.*
(c) *The diagonal line enables us to situate point C, which is the distance at which to situate the first division.*
(d) *The two divisions are equal as seen in parallel perspective.*
(e) *Continuing with the process, we can obtain as many subdivisions as we need.*
(f) *This method is valid for both a horizontal and a vertical surface.*

a

b

c

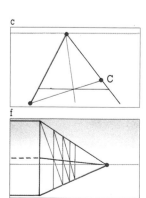

d

e

f

The Perspective of Regular Volumes
The Division of Planes in Parallel Perspective
The Division of Planes in Angular Perspective
87

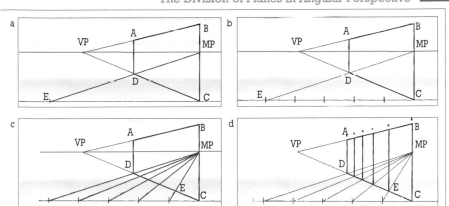

(a) *To divide a given space into equal parts, a measuring line is obtained by joining the measuring point (MP) with the lower, rear vertex of the space (D). The intersection of this line with the horizontal line that passes through the lower front vertex (C) gives the length of the measuring line.*
(b) *The measuring line is subdivided into as many parts as necessary.*
(c) *To transfer the partitions of the measuring line to the space in perspective, lines are drawn from each subdivision to the measuring point (MP).*
(d) *From each intersection of the lines drawn with the plane in perspective, vertical lines are added. These are the desired partitions.*

Division into Similar Parts

How to represent the front of a building with many windows, doors, or balconies that repeat themselves at equal intervals in parallel is a very common problem. The solution is to use the measuring line. Thanks to this technique, the vertical intervals can be divided as often as necessary. To obtain horizontal subdivisions, just divide the longer edge of the plane of the facade as often as necessary, drawing vanishing lines from each of them to the vanishing point of the drawing.

Contrary to the first impression, none of these methods is complicated. It is simply a matter of following the logic of the vanishing lines and the resulting reduction in size. If all that is required is the partition of the spaces in perspective as preparation for a pictorial work, they can even be shortened by calculating the sizes using rule of thumb and drawing freehand.

Method and Practice

In order to achieve a perfectly correct result, the methods of subdividing space in perspective should be carried out with a T-square, triangle, and ruler. Draftsmen work with these instruments, but artists never use them. A knowledge of this method will enable the artist to apply it freehand whenever it may be necessary.

Andreu Larraga Montaner (1862–1931), Pergola.
Museum of Modern Art, Barcelona.
A subdivision of equal spaces in perspective drawn intuitively, without taking any measurements or making any calculations, as is the case of the vast majority of pictorial representations in perspective.

MORE INFORMATION

• Parallel Perspective p. 76
• Angular Perspective p. 78
• The Perspective of Regular Volumes p. 84

THE DIVISION OF PLANES INTO EQUAL PARTS IN ANGULAR PERSPECTIVE

This section is a variation on those of the previous chapter. Now we shall try to divide spaces in angular perspective. Angular perspective shows objects (facades) in manner that is more common in drawing and painting than representation in parallel.

Dividing an Indefinite Space into Equal Parts

With an object of a given extension represented in angular perspective, the faces can be divided into equal parts using a variation of the method used in parallel perspective. In this case, each of the faces is considered as a space in perspective and the method applied to each one. First, the center dividing line is drawn in each of the two planes, starting at the center of the edge and extending it toward both vanishing points. The first vertical dividing line, which is made arbitrarily, should be wider on the more visible plane; the division of the less visible plane should be narrower due to the perspective. From the upper vertex, a diagonal line is drawn that passes through the intersection of the dividing line and the first subdi-

vision. The point at which this line intersects with the base of the plane establishes the following partition. The same method is used on the other side of the object in perspective.

Dividing Surfaces in Angular Perspective into Equal Parts

In order to divide two surfaces on either side of a corner into a certain number of equal parts, the method is the same as that used to divide a space in parallel perspective into a given number of parts. The only difference is that here we are dealing with two different spaces. In this case, a measuring line is also used at the height of one of the vertices of the corner and parallel to the horizon line. The measuring point is situated at the intersection between the edge of the corner

and the horizon line. From the measuring point, a line is drawn that passes through the most distant vertex of the right plane until it reaches the measuring line. The next step is to divide the two distances on the measuring line into the desired number of equal parts, which may or may not be the same on each of the sides. Now, simply join each of these divisions with the measuring point. The place in which they converge and cut the plane marks the subdivision of the space in correct perspective.

Dividing Repeated Parts in Angular Perspective

To render in angular perspective a building with a series of elements such as windows, balconies, and cornices that are repeated regularly, a variation of the system studied in parallel perspective is used.

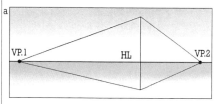

(a) In order to divide an undefined space in angular perspective, we begin by projecting the edge of an imaginary parallelepiped on the vanishing points.

(b) Two subdivisions are made on each side of the parallelepiped.

(c) A diagonal line is drawn from the upper part of the first division to the lower part of the parallelepiped.

(d) The intersections of the diagonal lines mark the distance at which to situate the remaining subdivisions.

The Division of Planes in Parallel Perspective
The Division of Planes in Angular Perspective
Perspective and the Urban Landscape

89

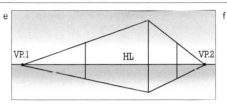

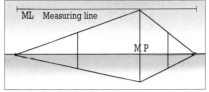

(e) *In order to divide established spaces in angular perspective, first we limit the number of faces of the parallelepiped.*

(f) *A horizontal line is drawn at the same level as the upper edge and the same width as the distance between the vanishing points. This is the measuring line.*

(g) *Both sides of the measuring line are divided into as many parts as wished (the same number of divisions on both sides).*

(h) *Each of the divisions is joined to the measuring point (MP). The points at which these lines intersect with each of the faces are where the subdivision in perspective should be situated.*

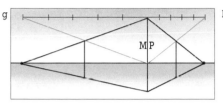

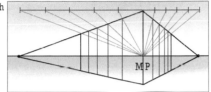

The first step is to consider how many areas you want to introduce into the drawing of the facades. Mark these divisions on the measuring line, extending them onto the facades as explained above. The horizontal subdivisions start from the edge of the corner, which should be divided into as many parts as is necessary. Projecting these subdivisions toward both vanishing points, you obtain two facades divided into vertical and horizontal areas.

This method is useful when drawing buildings. It is often difficult to draw the intervals between balconies, windows, and cornices freehand. When estimating the distances unaided, there is often too much space on the facade or not enough to accommodate all of the elements. The solution consists of drawing a note in perspective on a separate piece of paper or on the canvas itself. Work lightly in pencil so the projections (which can be easily erased) will be invisible in the final result. For an experienced artist who knows the different methods of perspective and is well practiced in applying them to different drawing problems, it is easy to calculate the subdivisions of spaces without using the methods described here.

Limits of the Subdivisions

Geometric perspective makes no allowance for rough measurements, but artistic painting and drawing are based on them. When subdividing spaces in perspective, there comes a moment when the partitions become so small that it is better to ignore them. Although this would be unacceptable in pure perspective, it is perfectly valid in artistic painting and drawing.

Joan Marti (1921), Venice. Private Collection. The subdivisions of the facades in perspective follow a rough, intuitive progression.

MORE INFORMATION

• Parallel Perspective **p. 76**
• Angular Perspective, **p. 78**
• The Perspective of Regular Volumes **p. 84**
• The Division of Planes into Equal Parts in Parallel Perspective **p. 86**
• Perspective and the Urban Landscape **p. 90**

PERSPECTIVE AND THE URBAN LANDSCAPE

The urban landscape is one of the genres most clearly affected by perspective. The elements that make up an urban landscape, built and arranged by people, are more concrete and more geometrically regular than purely natural elements. Perspective should be applied to the urban landscape in a natural manner, lending the forms their true harmony.

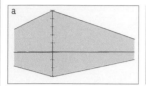
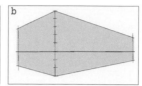
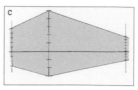

(a) *In order to obtain guidelines in perspective on a sheet of drawing paper, vanishing lines are drawn and the center edge is subdivided into as many parts as necessary.*
(b) *On the limits of the drawing, two vertical lines are drawn for the new subdivisions.*
(c) *By joining both series of subdivisions, the guidelines are obtained.*

Using these guidelines, obtained freehand, it is easy to draw urban perspectives.

Once the drawing is finished, the guidelines are erased and a convincing representation in perspective is the result.

Guidelines

There are times when an artist, sketching on a pad or small board in the street, needs to resolve an urban view in perspective. At such times, it is prob-ably impossible to develop the subject on the same piece of paper as there is not sufficient space to position the vanishing points. However, there is a solu-tion for this problem that simpli-fies the perspective and allows it to be applied to any drawing of an urban landscape.

First a general scheme of the buildings in perspective is drawn, encompassing them in a large box placed in angular per-spective. It is not necessary to

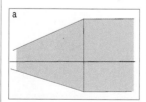
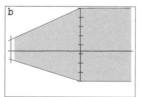
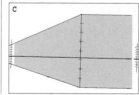

(a) *In parallel perspective, the guidelines are obtained from the facade in perspective.*
(b) *The front edge is subdivided into as many parts as necessary and a vertical line is drawn in the outer margin of the drawing, also subdivided into the same number of parts.*
(c) *By joining both subdivisions, the guidelines in perspective are obtained.*

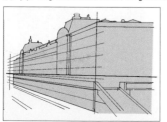

The elements of the facades can be arranged on these guidelines.

The result is an urban landscape in correct parallel perspective.

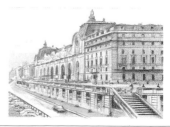

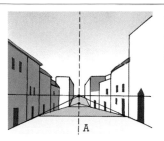

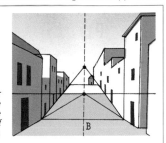

An observer (A) at the upper part of the street sees the slope recede below the vanishing point of a flat street.

An observer (B) in the lower part of the street sees the vanishing point above the vanishing point of a flat street.

extend the vanishing lines to each of the vanishing points, although it is advisable to mark the horizon line as a reference point. Then, on the nearest edge of this box, the necessary divisions are drawn (in accordance with the number of floors in the building).

On the outer limits of the drawing, the vanishing lines are cut off by a straight line on either side. These lines are divided into as many parts as there are in the center edge. These parts will, of course, be much smaller. By joining these partitions on either side, guidelines are obtained to help establish the correct distance between the floors.

In the case of parallel perspective, the solution is essentially the same. The only difference is that only two subdivided vertical lines are necessary—one on the closest edge, and the straight line placed at the end of the drawing to cut off the vanishing lines.

Inclined Planes in Parallel Perspective

Other lines in the urban landscape, apart from vertical and horizontal lines, can be represented easily using parallel or angular perspective. These lines are the slopes of roads, rises, and so on—a street with a steep hill, for example. Seen in cross section, all the buildings are perfectly vertical, so they are governed by the law of parallel perspective; the vertical

lines remain the same and the horizontal lines recede toward a point on the horizon. An observer at the top of the street sees how the lines of the plane of the street recede toward a point situated below the horizon. An observer at the lower part of the street, will see the edges of the sidewalk recede toward a point above the horizon. Bearing in mind these factors, it is easy to resolve the parallel perspective of a street with a steep slope.

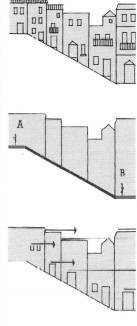

Other Slopes

Other inclined planes that are typical of an urban landscape are the roofs with two or more sides. A correct geometric solution for these elements, based on angular perspective, provides a vanishing point for each side apart from the two vanishing points typical in this kind of perspective.

In any sloping street, the vertical lines of the facades remain unchanged.

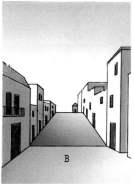

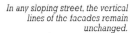

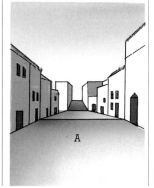

MORE INFORMATION

• The Division of Planes into Equal Parts in Parallel Perspective **p. 86**

DRAWING IN PERSPECTIVE

INTERIORS IN PERSPECTIVE (I)

The architectural elements of interiors can also be resolved in perspective. The most striking element of this genre are staircases. They can be seen as a series of rectangular prisms (the steps), which can be represented both in parallel and angular perspective. By simplifying this system, we can also resolve the perspective of the furniture.

Stairs in Parallel Perspective

You can imagine a flight of stairs as if it were a series of prisms or blocks that can be represented in parallel perspective. The problem consists of situating each step in perspective. To solve this, the subdivisions of the height of the stairs is situated on one of the side edges of an imaginary cube that encompasses the staircase. Then, a diagonal line is drawn that joins the front side of the cube with the opposite face (situated on the rear face). By extending each of the subdivisions toward the vanishing point, these lines will cut the diagonal line at different points. Each of these points indicates the height at which to situate each one of the steps.

A faster, more direct system consists of finding the vanishing point of the slope of the staircase. This can be done without calculation, situating it above the main vanishing point (VP.2). The vanishing line that runs toward this point starts from a vertex of the base of the reference cube (from the intersections of this vanishing line and the vanishing lines of the steps), and the height of each of the steps can be ascertained.

Stairs in Angular Perspective

To draw stairs in angular perspective, the process is the same as in the previous case. The difference is that the artist must take into account the two vanishing lines (right and left), the two planes, and also that the vanishing point of the slope should be situated exactly on one of the vanishing points—that of the side face of the reference box. We begin by drawing the reference

box in angular perspective and marking the height of the steps on the nearest edge. Each of these heights recedes toward the lateral vanishing point. By drawing a diagonal line that joins the lower vertex of the closest edge with the vanishing point of the slope, we obtain intersections with the vanishing points of the steps. Each of these intersections indicates the location of the steps. The diagrams on page 93 illustrate this concept.

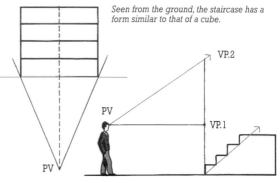

Seen from the ground, the staircase has a form similar to that of a cube.

Seen from above, the staircase reveals a slope that creates two vanishing points: that of the cube that appears at ground level (VP.1) and that of the slope, visible from above (VP.2). PV = Point of view.

In order to represent the staircase in parallel perspective, a line is drawn from the width of the lowest step.

Situating a line at the full height of the staircase and subdividing it into the distances corresponding to the steps, we have all the necessary reference points.

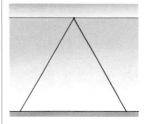

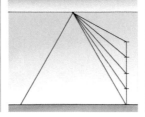

The subdivisions extend toward the vanishing point. The intersections between the projections and the diagonal line of the slope gives the height of the steps.

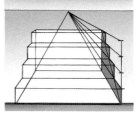

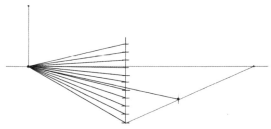

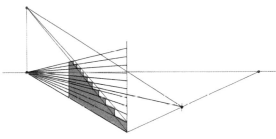

To construct a staircase in angular perspective, the vanishing lines of a cube are drawn obliquely, using the same proportions as the staircase with subdivisions retreating at the height of the steps. The vanishing point of the slope of the stairs is situated at an approximate height above the vanishing point.

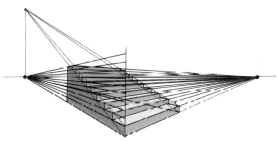

The slope is drawn by taking the points that correspond to the width of the stairs to a new vanishing point.

At the intersections of the different vanishing lines, the steps are situated.

MORE INFORMATION

• Angular Perspective **p. 78**

Furniture in Perspective

There is no special problem in drawing pieces of furniture in perspective. It is sufficient to encompass them in simple forms, such as a cube or prism, and to situate these forms in perspective. The irregularities of the furniture (seat and backrest, for example) can be resolved as if it were a staircase with two steps, using the method described earlier. Once the basic dimensions have been placed in perspective, it is merely a question of rounding off the form and introducing the decorative details.

Interior designers usually draw all types of furniture freehand, making rough calculation of the dimensions and proportions of the pieces. When it comes to situating them in perspective, they sketch simple forms that can encompass the whole of the piece, adding, if necessary, other partial features that help to define the irregularities of the volume or important details. Using these basic schemes, they can incorporate into the drawing all the elements of the piece. Once this is done, it is simply a question of coloring the drawing. A knowledge of representation in perspective is a great help for spotting possible mistakes in construction.

Interior Elements

Any object, however small, can be represented in perspective. But in drawing or painting an interior, perspective should only affect the larger volumes, which take up and define the space. Once this definition is obtained, the remaining small objects can be placed intuitively, without geometric calculations.

Furniture is drawn in perspective using "boxes" of the same size.

INTERIORS IN PERSPECTIVE (II)

Furnishing a space in perspective is another application of the principles of parallel
and angular perspective. It is not more difficult than to subdivide a space seen in depth.
The construction of an interior in perspective may be only the first step toward an
elaborate pictorial representation based on diverse compositional criteria.

A Room in Parallel Perspective

A room, which can be compared to a box seen from inside, may contain a variety of objects. To draw a room in parallel perspective, the first step is to represent the box—usually a rectangular parallelepiped, the base of which is a rectangle or a square. The vanishing point can be situated in the geometric center of the paper. Then, four vanishing lines are drawn to mark off the floor, the walls, and the ceiling. The back wall can be

A room in parallel perspective is drawn by starting with a cube seen from inside. At the center is the vanishing point toward which the vanishing lines of each side recede.

situated freehand, calculating the approximate depth of this box-room. Inside the box the artist can draw all the elements in the room: doors, windows, pictures on the wall, and so on.

Using the vanishing lines as guidelines, each piece of furniture is situated.

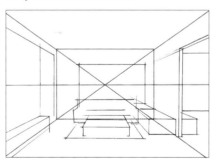

Calculating the sizes can be done easily by projecting each of the elements toward the vanishing point.

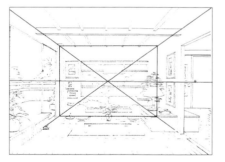

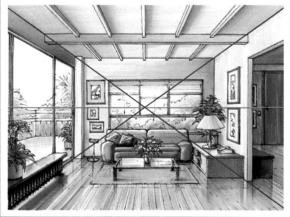

MORE INFORMATION

- The Perspective of Regular Volumes **p. 84**
- Interiors in Perspective (I) **p. 92**
- The Division of Planes into Equal Parts in Parallel Perspective **p. 86**
- The Division of Planes into Equal Parts in Angular Perspective **p. 88**

The result may contain a great amount of detail.

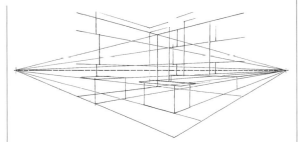

These are all flat elements that are a result of partitioning the walls of the room. The volumetric items (chairs, tables, bed, armchairs, bookcases, lamps, and so on) are placed by situating the base of the object on the floor in perspective (a square in perspective of approximately the same size as the object). The only thing to take into account is that the lines parallel to the horizontal lines all recede toward the same, central vanishing point, and the vertical lines decrease in size in the distance. If we wish to draw a lamp hanging from the ceiling, for example, its location is extended down to the floor to simplify the calculation of its size; then it is drawn hanging in its true position.

An open parallelepiped in angular perspective can represent an interior in this type of perspective.

A Room in Angular Perspective

To draw an interior in angular perspective, the same box is drawn with two vanishing points. When the box is finished, all the elements it contains can be added. The flat objects should follow the same rules of perspective as the walls or the planes on which they stand; and the volumetric objects should be situated in space in relation to the two vanishing points.

If figures are to be included in the interior, the problem is merely one of situating them correctly and maintaining their proportional height. Starting with one figure, it is possible to find the proportions of the others. Draw vanishing lines from the first, taken from points such as the top of the head, the neck, the waist, the knees, or soles of the feet. The remaining figures can be drawn on these vanishing lines, reduced in size accordingly. This is only possible if the figures are lined up on the same, ideal plane; otherwise, it will be necessary to calculate the reductions in size using the size of the surrounding objects as a reference point.

Interiors as a Pictorial Subject

The interior of a house, a church, a palace, with their furniture and figures, has been a major pictorial motif throughout history: small, cozy rooms, as in the masterpieces of Dutch painters in the seventeenth century; grandiose halls, temples, and palaces, with scenes of court life, typical of the Baroque period; the bourgeois intimacy of Impressionism; and so on. All of these subjects contain elements that are impossible to draw without applying the rules of perspective. Yet this is only a part of the compositional method used in these works. These great paintings are carefully calculated to achieve a harmonious whole from a great variety of objects and figures inside a limited space. The choice of the objects (for their size, form, and color), the illumination of the scene, the balance between the lines of the drawing, and so on—these, among others, are the factors that augment a knowledge of perspective to achieve some of the most unforgettable pictorial scenes in the history of art.

Grids for Interior Painters

Interior painters usually use paper ruled in perspective so as to furnish any interior without having to calculate the perspective of each object. The large number of grids in parallel perspective produce a highly accurate calculation of the distances and sizes of the furniture—an essential calculation for producing a faithful representation of an interior.

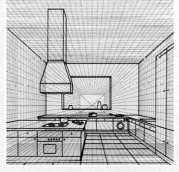

Grids can aid in the accurate representation of interiors without any need for calculations.

Original title of the book in Spanish: *Perspectiva y Composición*
© Copyright Parramón Ediciones, S.A. 1998—World Rights.
Published by Parramón Ediciones, S.A., Barcelona, Spain.
Author: Parramón's Editorial Team
Illustrators: Parramón's Editorial Team

Copyright of the English edition © 1999 by
Barron's Educational Series, Inc.

All inquiries should be addressed to:
Barron's Educational Series, Inc.
250 Wireless Boulevard
Hauppauge, New York 11788
http://www.barronsedeuc.com

International Standard Book No. 0-7641-5104-5

Library of Congress Catalog Card No. 98-74346

Printed in Spain

Note: The titles that appear at the top of the odd-numbered
pages correspond to:

The previous chapter
The current chapter
The following chapter